Foreword

In this age of rapid communications, it has become more and more difficult to identify thought and creativity as belonging to a region. With the broad dissemination of illustrated periodicals and the proliferation of traveling exhibitions, new concepts can affect the national consciousness very quickly; and, with relative ease, the artists themselves are able to move from region to region.

But the notion of regionalism persists, perhaps most tenaciously in the Northwest. The very affective physical environment has its influence on the artists who choose to live in the Northwest, though whether they respond to it literally or not is another matter.

There was a time, roughly between 1945 and 1970, when it was believed that art of the Northwest could be much more readily recognized. If it was not a unified school, at least it presented a body of work that possessed distinctive though often intangible characteristics. It is this productive period that is treated in *Northwest Traditions.*

I wish to acknowledge the devoted efforts of the several individuals named elsewhere, who have helped produce this exhibition and catalogue. I wish also to thank Mr. and Mrs. Bryant R. Dunn and the trustees of the Charles E. Merrill Trust who have helped establish a publications fund that makes possible the broad distribution of the catalogue. Through an innovative support program of the Seattle Arts Commission, 5,000 copies of the catalogue are being made available at no charge to the public.

Willis F. Woods
Director

Morris Graves
Moor Swan, 1933

Oil on canvas, 36 x 34¾
Gift of West Seattle Art Club
Katherine B. Baker Memorial Purchase Prize
19th Annual Exhibition of Northwest Artists
Seattle Art Museum

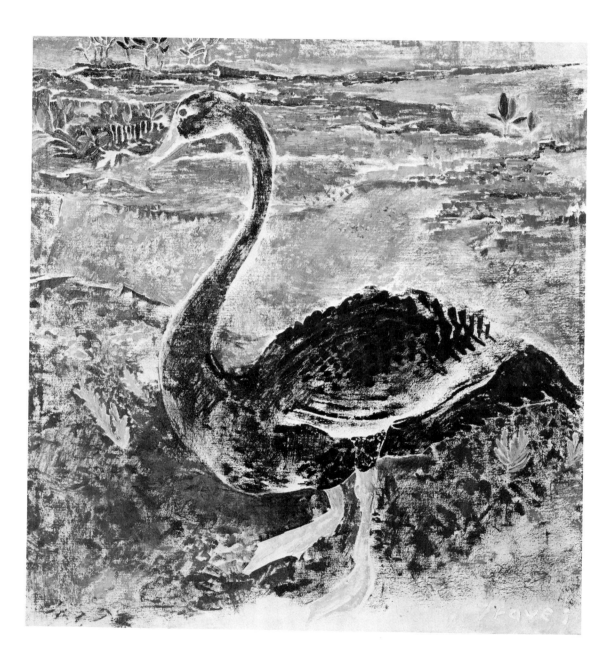

Northwest Traditions

Organized by

Charles Cowles
Curator of Modern Art
and Sarah Clark
Associate Curator of Modern Art

Essay by

Martha Kingsbury
Associate Professor of Art History
University of Washington

Seattle Art Museum **June 29- December 10, 1978**

This catalogue was made possible by support from the Seattle Arts Commission.

Copyright©, Seattle Art Museum, 1978

Library of Congress
Catalog Card Number 78-59777

ISBN (cloth) 0-932216-00-5

ISBN (paper) 0-932216-01-3

Printed in the United States of America.

Introduction

During the 1940s and fifties, America achieved international status as a center for the visual arts and the Northwest produced its first generation of nationally acclaimed artists. The purpose of this exhibition, "Northwest Traditions," is to focus on the masters of this heritage, seventeen artists whose work spans the period from the mid-forties through the early sixties, the rise and culmination of the Northwest School. The indication of particular artistic characteristics and growth in the region is found, for example, in the reviews of the Northwest annuals during the short period of the late thirties to early forties. Whereas a critic for the *Magazine of Art* in 1937 saw no dominant style in that year's regional exhibition,[1] another writer for *Art News* in 1943 reported a heightened sense of despondency and somber communication through the use of black in the work of several artists such as Mark Tobey, Guy Anderson, and William Cumming.[2] During the forties, the first idea of a Northwest School of "originality, special techniques, and restless visual poetry"[3] occurred, primarily however, through the critical attention to the one-man exhibitions of Tobey and Morris Graves at the Willard Gallery in New York.[4] Also at this time an important spokesman for the arts of the region, Kenneth Callahan, wrote numerous articles for local and national journals. After his first one-man exhibition in New York in February, 1946, he wrote a major essay for *Art News* in which he stated that the painting styles of the Pacific Northwest were not uniform but generally unified by a "consistent use of broken forms and greyed color; preference for tempera as a medium; leanings toward symbolism and expressionism; and the influence of Oriental art." He pointed out that the philosophical and intellectual concepts of the position of man in nature and of the artist in the postwar world were the basis for the subjective-mystical style of the regional artists. Tobey's "white writing" technique and the heavily impastoed semi-abstractions of C.S. Price were strong formal influences.[5] The article setting the tone for art criticism in the fifties was the September, 1953, issue of *Life* magazine where six full pages accented the mystic art and life of Anderson, Callahan, Graves, and Tobey.[6] Persistent reinterpretation of a "Northwest School" continued until the general agreement of a stylistic union of regional, national, and international artists in the exhibitions at the Seattle World's Fair in 1962.[7]

The first purpose of this current exhibition, therefore, is to assess the issues of this heritage. These seventeen artists represent the nucleus of those who came to the forefront during the forties and fifties, many of whose work has continued to possess energy and quality throughout the sixties and even seventies. Martha Kingsbury, in her perceptive essay, analyzes the work of a group of influential artists and relates their individual artistic development in the Northwest to a wider context of modern art, the romantic tradition, and socio-political conditions of the era.

The second purpose is to document for the first time the major works of the permanent collection of Northwest art in the Seattle Art Museum. The modern art collection of the museum consists of over fifteen hundred paintings, sculpture, prints, and drawings; a major segment of the corpus of paintings forming half of this total collection. The importance of Northwest art is stated clearly by the fact that over half of the modern European and American collection represents work of this region and that three-fourths of the paintings alone are by Northwest artists. Whereas the collection of prints and drawings ranks numerically second in overall size with one-fifth by Northwest artists, the collection of sculpture is the lesser category in size with three-fourths by regional artists.

In consideration of the origins of the Northwest collection, Dr. Richard E. Fuller, the founder, patron, and first director of the Seattle Art Museum, formed most of the collection with the remainder generated by prizes from the Northwest annuals and private gifts. Dr. Fuller primarily bought work directly from artists and frequently from their one-man exhibitions at the museum. For example, three of the eight paintings by William Cumming in the collection were in his one-man exhibition in 1941; in the present museum exhibition are two: *Worker Resting* and *Abandoned Factory.* Also on exhibit are two of the four paintings selected by Dr. Fuller from the Ambrose Patterson retrospective in 1961: *Summer* and *Portage Bay.* The most significant number of works purchased by Dr. Fuller from an artist and comprising a major portion of that artist's representation in the Northwest collection belongs to Kenneth Callahan. Because of Callahan's devotion to the museum from 1933 to 1952, it is, perhaps, not unusual to find that twenty-one of his thirty-four paintings were purchased by the director during the 1930s and forties. Two major works from the fifties selected by Dr. Fuller are *Riders on the Mountain* and *Echoes of Ancient Battle;* the latter painting was retained after Callahan's one-man exhibition at the museum in 1955.

Approximately a third of the large holdings of the

George Tsutakawa
Obos No. 2, 1958

Stained cedar, 22½ x 15½
Collection of Anne and John Hauberg

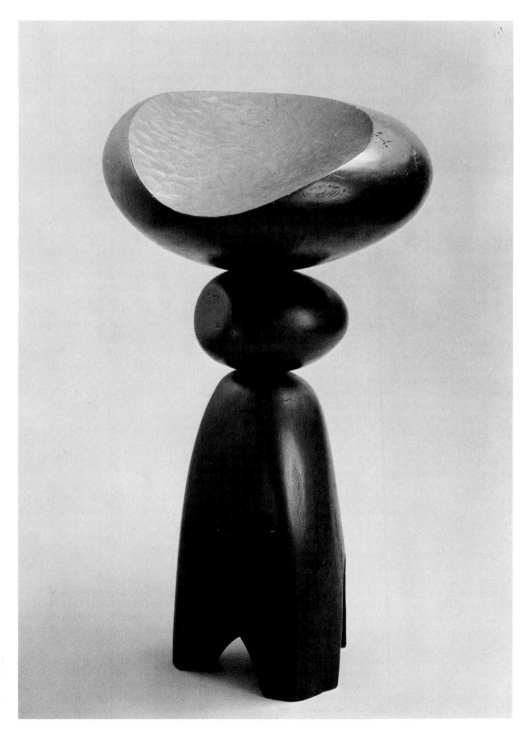

works by Tobey and Graves were purchased by the director. Although Dr. Fuller chose Tobey's *Moving Forms* and *Table and Ball* while visiting the artist in London, Fuller's collection of Tobey's work was primarily formed during the forties when the artist resided in Seattle. Nine of the thirteen Seattle purchases are included in the exhibition, ranging from *Working Man* (one of six selected from Tobey's 1942 one-man exhibition) to *Golden Mountains.* Although *Electric Night* had been in Tobey's exhibition at the Willard Gallery in 1944, Dr. Fuller later bought it from the artist. Dr. Fuller's passion for collecting and keen sensitivity to an artist's work is also characterized in his selection of Graves' paintings. In November of 1946, eight of Fuller's thirteen purchases from Graves were added to the museum collection; five of this major acquisition are in the exhibition such as *Owl* and *Waning Moon: No. 2.* Other artists in the museum collection whose works represent a significant ratio of direct purchases from studios are Richard Gilkey (two of six in the collection), Leo Kenney (three of nine), and C. S. Price (two of five).

Whereas over half of Dr. Fuller's acquisitions for the Northwest collection were purchased from artists, approximately one-fourth came from Seattle galleries, primarily those directed by Gordon Woodside, Otto Seligman, and Zoe Dusanne, and from the Willard Gallery in New York. Although Dr. Fuller's purchases from the Gordon Woodside Gallery are a major portion of the collection, his selections from the Seligman Gallery, Dusanne Gallery, and Willard Gallery are probably the more significant in relation to several artists' representation in the collection. For example, Dr. Fuller bought five works by Tobey from each of his dealers, Otto Seligman and Marian Willard. *Canals,* from the Seligman Gallery, is the only painting the museum owns which was exhibited in the Venice Biennale of 1958 where Tobey won first prize. Paul Horiuchi had his first one-man exhibition in 1957 at the Zoe Dusanne Gallery where Dr. Fuller chose *Torrential Rains.* Another important Fuller selection from that gallery for the museum's collection was Horiuchi's *Genroku Era.* Although in quantity too few, the quality of William Ivey's work in the collection is a result of the long working relationship between Dr. Fuller and the Woodside Gallery. Similarly in proportion of quantity to quality is the total works by Anderson in the Northwest collection; two were purchased from the Seligman Gallery, one of which, *Primitive Forms II,* is in the exhibition. Whereas the director worked with the dealers to

secure works by such artists as Anderson, Graves, Horiuchi, Ivey, and Tobey, he bought only one work by Callahan, *Chasm,* for the collection from the artist's dealer, Maynard Walker, in New York.

One-fifth of the Northwest collection was formed through purchase prizes in the Northwest annuals, a juried competition from 1916 to 1975. One-eighth of the collection are Dr. Fuller's purchases, irrespective of jurors, from these group exhibitions. In the museum's large holdings of Graves and Callahan, each artist had only one Northwest annual award: Graves' *Moor Swan* of 1933 and Callahan's *The Seventh Day* of 1953. Two works by Anderson in the collection represent prestigious awards from these annuals; *Sharp Sea,* for example, won the Katherine B. Baker Memorial Purchase Prize of 1944. In 1940 Tobey won this same prize with his painting, *Modal Tide.* Although Tobey's *Forms Follow Man* was in the 1941 annual, the painting did not enter the collection until 1950 when Dr. Fuller acquired it from the Willard Gallery. In the museum's representation of several artists, the annuals were the most direct source for the Northwest collection; Cumming's *Two Loggers* and Louis Bunce's *Still Life* are examples of their works exhibited in these large group exhibitions which generated half of their total number in the collection. In the small number of paintings by James Fitzgerald, Carl Morris, and Margaret Tomkins, the proportion stemming from the Northwest annuals prizes is high, such as Morris' *Out of the Coulee,* and personal preferences of Dr. Fuller such as Fitzgerald's *Resurgent Sea* and Tomkins' *Anamorphosis.*

One-fifth of the museum collection of Northwest art has been formed through the generosity of over seventy donors. The Sidney and Anne Gerber Collection not only has been the prime source of contributions, but it also placed in the museum the works of such masters as Anderson, Price, and George Tsutakawa, whose quantitative representation is regrettably very small. The Seattle Art Museum Guild, the second highest contributor, has continued to support curatorial selections for the collection. In the corpus of works by Tobey and Graves, the Bloedel family has given important works such as Tobey's *Parnassus* and *Orpheus* and Graves' *Leaves Before Autumn Wind* and *Spring.* The late Mrs. Thomas D. Stimson's gifts of Tobey's *E Pluribus Unum* and Graves' *Sea, Fish, and Constellation* were purchased from the Willard Gallery, which is also where the major donations of the Bloedel family originated. Also, Norman Davis

was the source of one of the continuing purchase prizes for sculpture in the Northwest annuals. Finally, the museum's collection has been enriched through several major gifts from these artists, such as *Night of Soliloquy* by Callahan and *Drums for Drama* by Horiuchi.

As reflected in this exhibition, the present focus of the museum's collection of Northwest art is a large group of paintings from the period of the forties through the mid-sixties. The numerical imbalance of several artists in the exhibition, such as Anderson to Tobey, shows the existing status of the collection. The loans from private collections to this exhibition of the work of Hilda Morris and George Tsutakawa significantly point to the general overall deficiency of the sculpture collection. Since the establishment of the department of modern art in 1975, the museum has worked toward further expansion of the collection of Northwest art, one of the museum's richest areas of continual cultural development.

Sarah Clark
Associate Curator of Modern Art

Footnotes for Introduction

[1]Callahan, Kenneth. "Northwest Artists at the Seattle Art Museum." *Magazine of Art,* November 1937.
[2]"Northwest Annual." *Art News,* 1-14 November 1943.
[3]Louchheim, Aline B. "Graves' New World." *Art News,* 15 February 1945.
[4]Gibbs, Josephine. "Tobey the Mystic." *Art Digest,* 15 November 1945.
[5]Callahan, Kenneth. "Art of the Pacific Northwest." *Art News,* July 1947.
[6]"Mystic Painters of the Northwest." *Life,* 28 September 1953.
[7]*Seattle World's Fair . . . 1962.* Seattle: Century Twenty-One Exposition, 1962. Bound volume, containing four catalogues: *Masterpieces of Art, Art Since 1950, Northwest Coast Indian Art, Northwest Art Today – Adventures in Art.*

Ambrose Patterson
Summer, 1952

Oil on canvas, 24⅛ x 30
Eugene Fuller Memorial Collection
Seattle Art Museum

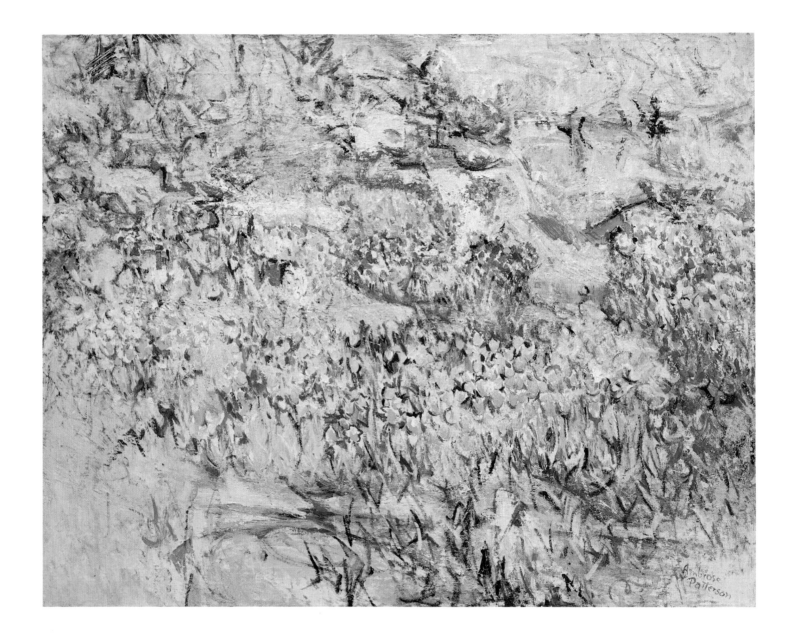

Four Artists in the Northwest Tradition

By Martha Kingsbury

The art that has come to mean, for many people, "Northwest Traditions," resulted from the confluence of overlapping interests and strong energies of several artists in the Seattle area around 1940. The best known are the artists Mark Tobey and Morris Graves, and their close associates Kenneth Callahan and Guy Anderson. The present selection of paintings and drawings concentrates almost exclusively on these artists' works. The goal of this essay is a comprehension of their works both within the narrower context of the Northwest locale during the decades of World War II and the Cold War, and within the wider context of modern art.

In a broader sense, however, these artists were part of a larger "tradition," which barely preceded them in the Northwest but certainly will outlive them; that is, the tradition of excellence within great diversity, which is ultimately a major contribution of the modern epoch. Hopefully, the present selection of works at least hints at the viability of an energetic pluralism in the Northwest, within which the narrower tradition, examined here, arose.

To take as tradition, developments barely a generation, a third of a century, old at the present writing, may appear anomalous; and yet the circumstances are compelling. The newness of the city itself accounts for their being the "first," or at least the first native-born, generation to achieve substantial and innovative work. The apparent consolidation of American art activities in New York, shortly thereafter, may account for the obsessiveness with which their achievements are clung to by some in the Northwest, who embrace the memory of these artists and their works with the deep stubborn devotion that the word "tradition" implies.

Callahan, Anderson, and Graves were all born in the Northwest in the first decade of the century (1905, 1906, and 1910, respectively). Seattle, in the decade of their birth, was a city "on the edge" in several senses: on the edge between a nineteenth century past almost entirely constituted of pioneering and frontier activities, and a twentieth century urban future that would include participation in the higher forms of culture. How thin an edge it was, was suggested by the 1906 visit to Seattle of the renowned European actress Sarah Bernhardt to play Camille and Sappho. "Bernhardt told her manager she would like to go hunting for bear, for she thought there must be good hunting in the dense woods about here. After much scurrying around, a bear — a tame one — was found... with much maneuvering he finally ambled into view.

When Mme. Bernhardt caught sight of a bare place on his neck where the hair had been worn away by his collar, she was furious" and ultimately bagged several birds instead.[2]* Seattle also perceived itself as "on the edge" geographically, between the American-European civilization inland, and the new realms of Alaska and the Orient beyond its harbors. The 1909 Alaska-Yukon-Pacific Exposition projected this image forcefully — in its title, its publicity, and its emblem of three lovely women, symbolizing Seattle herself, the ancient cultures of the East, and the wilderness of the Yukon. Like the three Graces or the Fates, they were proposed as the region's pride and destiny.

During the childhood and adolescence of Callahan, Anderson, and Graves, Seattle began to acquire the rudiments of a cultural life. Artists whose origins were elsewhere brought their experience to the city's fledgling institutions. Mark Tobey, trained in Chicago and New York, joined the staff of the innovative Cornish School in 1922, eight years after its inception. Ambrose Patterson, an associate of the postimpressionists and the fauves in Paris for more than a decade, brought his knowledge of European art and bohemian ways to the University of Washington in 1918. In the 1930s, the university broadened its artistic concerns under the direction of Walter Isaacs, who was interested in European methods of instruction. Hence, Alexander Archipenko, Amédée Ozenfant, and Johannes Molzahn were visiting teachers at the university during the latter half of that decade.

Opportunities to show and see work became regular occurrences during the same period; for example at annual exhibitions of the Seattle Fine Arts Society from 1916, through the Camera Club from 1925, and at the very active Northwest Printmakers annuals from 1929. Eventually, institutions to house art, on a permanent if modest basis, followed with the opening of Horace C. Henry's collection to the public in 1927 and Dr. Richard E. Fuller's provisions for the Seattle Art Museum in 1933. Both Henry's and Fuller's museums became significant for the traveling shows they hosted, as well as for their own collections of predominately Barbizon and American landscapes in one case, and excellent Asian art in the other.

In an aura of optimism and new starts, Seattle's artists also attempted more experimental and independent (if short-lived) associations. There was, for example, a Cherry Street Art Colony in the late twenties, involving a number of artists and

*Numbers refer to items in the bibliography (on page 62) from which particular information has been drawn.

9

Mark Tobey
Farmer's Market, 1941

Gouache on board, 19⅝ x 15⅝
Eugene Fuller Memorial Collection
Seattle Art Museum

writers including Kenneth Callahan. In the early thirties an artist's cooperative gallery, the Northwest Art Galleries, was tried.

While the Depression severely handicapped some of these efforts, the government programs it spawned were ultimately of considerable benefit particularly to the area's young and less established artists. Kenneth Callahan and Ambrose Patterson received commissions for public murals from the Treasury Department. Morris Graves received support from the Federal Art Project in 1936 and 1937, with the time and freedom to devote to painting which that implied; and Mark Tobey received similar support briefly in 1938. Guy Anderson taught at the WPA's Spokane Art Center in 1939-1940 and found his association with Carl Morris and other artists close and intense.

That the area's achievements, new as they were, received national acknowledgement in the thirties must have been heartening. In 1933 Seattle provided work for the Museum of Modern Art exhibition, "Painting and Sculpture from Sixteen American Cities." Kenneth Callahan, still in his twenties, was included. The stubborn optimism and irrepressible ambitions of these young artists can be sensed from the scale of a mural Callahan undertook (without commission or destination) over the next couple of years. Called *Logging in the Northwest,* it was painted on separated panels twelve feet tall and eventually grew to 132 feet in length. Something of the same optimistic and ambitious nature must lie behind Morris Graves' restless alternation through the thirties, between travel, and returns to the Northwest to build or find studios. Graves began the decade with two trips to the Orient in the merchant marine, traveled to Los Angeles, Texas, and New Orleans, to Los Angeles again with Guy Anderson, and then to New York more than once, and to Puerto Rico. But between these travels he converted a stable into a studio in Seattle with Guy Anderson, began a studio north of Seattle on family property, eventually converted a bunkhouse there to a studio (which burned down), moved into a half-burnt-out house further north, and finally in 1940 began building (at first only a shack) on the nearby Fidalgo Island site, called "The Rock," that was identified with him through the early forties —until the racket of a new naval air station drove him off "The Rock" and he began a house on the mainland at Edmonds, Washington.

By the late thirties, therefore, an institutional and social framework had been raised for artists' activities, but the art scene itself was still relatively

small and informal. A modest Seattle publication of 1937, *Some Work of the Group of Twelve,* brought together the diversity of styles and experiences that characterized the area's artists then. One gathers from other sources that the associations among artists of different origins, generations, and inclinations, were nearly as casual and wide-ranging as the alphabetical juxtapositions in the "Group of Twelve." In retrospect, the beginnings of separate clusters can be recognized, but their contours shift with the perspective of the viewer. A "downtown group" or a group around Dr. Fuller at the Seattle Art Museum was variously intrigued by local Northwest subjects and by Asian art; while the university group might have seemed a little like a Northwest branch of the School of Paris. Yet this is mainly a retrospective view, and the intensity of rapidly developing styles and mutually sustaining discourse seems not to have pervaded such loose groupings until Tobey, Graves, Anderson, and Callahan became so involved around 1940.

As the war approached and the Depression decade drew to a close, the early phase of Seattle's art seemed to end, and a period of transition intervened with the dissolution of certain patterns and a regrouping of individuals and interests. Government patronage of the arts atrophied and disappeared. In 1939, Nellie Cornish resigned from the Cornish School after serving the school twenty-five years and facing its increasing financial difficulties. Tobey returned to Seattle in 1938, having been most of the thirties in England; Graves became friends with Tobey, settled into serious studio building, and brought his restless wandering to a temporary halt; Guy Anderson, after the stimulating experiences of isolated intimacy at the Spokane Art Center, returned to Seattle in 1940. Margaret Tomkins from Los Angeles and Carl Morris became close associates of these others and brought additional ideas to the group at this time. On the other hand, the talented and sensitive Sherrill van Cott who became a close friend of Graves during these years, was ill, and died in 1943. The war soon scattered the Asian artists from the city: Tokita and Nomura, both included in "The Group of Twelve" and the latter also in the 1933 Museum of Modern Art exhibition, were sent to detention camps, while George Tsutakawa, an associate of Graves and Anderson, and later of Tobey, enlisted by 1942. It was in this atmosphere of tension and distress, 1938-1942, that the close association of a few artists gave rise to the art that has become, for many, the Northwest's traditions.

An account of Seattle culture in 1940-1941 by writer Nancy Wilson Ross suggested that behind the new institutions and groupings, the bold and confident beginnings, a certain hollow disappointment could be felt. The promise of the century's opening years had not been fulfilled. The 1909 exposition, Ross wrote, had announced to the world Seattle's "awareness of the elements which should, by geographic placement, determine its development and give it quality." But now "among her losses must surely be counted a failure to effect a cultural rapprochement with other lands and peoples on the shores of the Pacific." International cultures existed only in "little back eddies," and a visitor to the city would likely see "only a synthetic culture, a syndicated ghost of New York." Ross treated the city's esthetic sense still more harshly — its callousness and ignorance regarding the difficulties of the Cornish School, its failure to appreciate and collect the arts of Northwest Indians, and its backwardness when confronting abstract art. What she called "the great IS IT ART? row" of 1940 [an explosion of controversy over prizes awarded to abstract painting at the Northwest annual] actually involved Mark Tobey's painting *Modal Tide,* although she kept his name out of her account. Instead, she mentioned Tobey as one of the few painters to utilize the public market in his art — "the great public market down on the waterfront" with which no other Seattle sight could compare. She ended her account of Seattle with a hopeful, if elliptical, reference to Seattle artists. Little attention, Ross concluded, "has been paid to a native cultural growth, pushing its slow way toward expression among a scattered group of musicians, painters, writers, dancers, living on the city's fringes — anonymous and often poor ... With some community understanding and support Seattle could make a truly indigenous and original contribution to American culture."[25]

Ross wrote from personal conviction and from knowledge of Seattle artists, and did a good deal to further their interests and her convictions. Already in 1939, she had entertained a friend from New York, the gallery owner Marian Willard, and taken the opportunity to introduce Tobey to Willard and to visit Graves' studio with her. Willard handled both men's works afterwards. The cultural rapprochement Ross desired was ultimately exemplified for her by Tobey and Graves; and one found her citing their works and statements to explain "What is Zen?" to readers of *Mademoiselle* in January, 1958.

Nancy Wilson Ross's 1941 account stood on

Louis Bunce
Still Life, 1962

Oil and pencil on canvas, 45⅜ x 57⅜
48th Annual Exhibition of Northwest Artists Purchase Fund
Seattle Art Museum

the brink of a new era for art in the Northwest. In the following decade and more, the searching insistence of herself and others was rewarded by increasingly rich, delicate, often symbolic paintings that answered fully her call for art both "truly indigenous" and an "original contribution to American culture." Tobey, Graves, Callahan, Anderson—and eventually other artists whose work seemed directly or elliptically related to theirs—were perceived in this way, and the best of them not only in the Northwest but far beyond, across the United States and in Europe. While other artists, of equal strength or originality, in some instances related more to international currents and did not lend themselves to the same sort of perception or discussion during the forties and fifties. Thus Ambrose Patterson eventually returned to the sensual glories of postimpressionist perceptions, and Walter Isaacs persistently impressed the rigors and nuances of Cézannesque construction on innumerable students. Leo Kenney evolved a complex and deeply personal mode ultimately related to surrealism. Wendell Brazeau and Spencer Moseley developed an intellectual art based on the most formalist and abstract twentieth century innovations, a controlled and forthright art capable of dignity and authority but also of wit and elegance. Abstract expressionism, within a decade, affected Carl Morris and Louis Bunce. Alden Mason found through abstract expressionism the freed energies and spontaneity that never deserted him, whatever style and imagery he explored. William Ivey developed his abstract expressionism directly from his experience in San Francisco with Mark Rothko, Clyfford Still, and others in the forties. The force and breadth of the vision he acquired never diminished. Still, it was not this twentieth century pluralism, but the narrower specifically "Northwest Tradition" that drew warm acclaim from critics and that has been selected to receive the attention of the historian.

The existence and then the characterization of what came to be called the "Northwest School," began about the same time Nancy Wilson Ross entertained her friend, Marian Willard. That year, 1939, four works of Graves were included in a Museum of Modern Art exhibition of art from the Federal Art Projects, and they evidently attracted close attention, for over thirty Graves works were included in the same museum's 1942 exhibition, "Americans 1942, Eighteen Artists from Nine States." The same year, 1942, Tobey was included in a Metropolitan Museum of Art exhibition, Graves

was shown in a three-man show at the Phillips Gallery in Washington, D.C., and Marian Willard held the first of many Graves exhibitions in her New York gallery. In 1943 the "Romantic Painting in America" exhibition included Tobey and Graves. From 1944, Marian Willard carried both Tobey's and Graves' work, and her exhibition catalogue of Graves' work that year included one of the earliest clear characterizations of him and his art as "mystic" and oriental—an approach immediately broadened, even by 1945 and 1946, to characterize other Northwest artists. When Tobey condemned the national and regional in art and called for "the understanding of this single earth," in the 1946 catalogue of the Museum of Modern Art's "Fourteen Americans" exhibition, it was probably taken as evidence of mystical orientalism rather than the contrary. The East Coast's image of Northwest mystics received positive and explicit support from the source itself in Kenneth Callahan's extensive report (roughly eight pages) on "Pacific Northwest" in the July, 1946, issue of Art News. Although he emphasized that "no standardized formulas set our painting apart in a fixed regional school," he nevertheless characterized the form and content of a "unified rather than uniform" development in terms that became widely accepted, and he spoke to the causes of the development in terms which have been relatively forgotten and to which we will return.

The history of the concept itself, of there being a "Northwest School" has been written elsewhere.[18] The concept's widest publicity was probably the 1953 Life magazine article, "The Mystic Painters of the Northwest," which devoted six pages of full color to Tobey, Callahan, Anderson, and Graves. And Life's choice of these four as the nucleus was repeated in 1957-1958 when the U.S. Information Agency sent works by the four, plus four sculptors' works, on an international tour. Indeed, time seems not to have altered the sense of these four as a nucleus, and they are the focus of the following examination also. Graves was honored with a major exhibition at the Whitney Museum in 1956, and Tobey's slower, wider spreading fame led to the international prize for painting at the 1958 Venice Biennale, a large exhibition at the Musée des Arts Décoratifs in Paris in 1961, and a retrospective at the Museum of Modern Art in 1962. While these individual honors seemed to confirm the significance of the "Northwest School" (or the more vaguely defined "Ecole du Pacifique" as it was imagined from Paris), they did little to alter or

Leo Kenney
Third Offering, 1948

Oil on canvas, 41¼ x 25⅜
Lowman and Hanford Purchase Prize
34th Annual Exhibition of Northwest Artists
Seattle Art Museum

deepen understanding of what had really happened there and why.

The characteristics assigned by the mid-forties stuck through the fifties and sixties, much as Callahan had summarized them: broken form and greyed color, a preference for tempera, "leaning toward symbolism and expressionism; and the influence of Oriental art...a mystic essence."[39] If the latter, more vague, terms have often dominated discussion of the work it is perhaps to the point to keep the former in mind when examining this art today. The nature of their "leanings toward symbolism and expressionism"[39] and the reasons for their choices of form and media are not entirely obscure nor unrelated.

The notion of a "mystic essence" suggested by Callahan in 1946, made it seem appropriate, for example, that Graves' catalogue of his 1948 show at the Willard Gallery should have a preface taken from *Elements of Buddhist Iconography* by Ananda K. Coomaraswamy; even though the text must have been more poetically suggestive than informative. Coomaraswamy's writing, which did so much to introduce Westerners to Asian art and esthetics, was mentioned by Graves in 1956,[34] and Guy Anderson recalls that they had all read him eventually, along with Joseph Campbell and Heinrich Zimmer. These were writers concerned not only with Asian systems of thought and belief, but with comparative religion and mythologies of worldwide scope. Often Jungian in basic orientation, they sought a world culture and a world consciousness through comprehension of the previously multiple and separate Western and Eastern systems. This universal perspective was the context within which the painters read Coomaraswamy or the *Bhagavad Gita,* and this was emphasized by Coomaraswamy himself when Graves finally sought him out in person in 1947 at the Boston Museum of Fine Arts. Guy Anderson recalls that Graves was shown special scrolls at his request, and treated very well. They talked about East and West, and when he left Graves asked for any advice. "And Coomaraswamy said, 'My advice to you, young man, is go and pay tribute at Walt Whitman's grave.' So this was a little earthshaking —in that we all loved, of course, Walt Whitman— but it was a little hard to make that cross over immediately, you know...."[60]

Yet cross over they did, again and again, in their art and in their thought. The earliest, and one of the very few, attempts to see these artists' links to others rather than their differences, was the

Morris Graves
Waning Moon: No. 2, 1943

Gouache on paper, 26½ x 30½
Eugene Fuller Memorial Collection
Seattle Art Museum

Museum of Modern Art's exhibition of "Romantic Painting in America" in 1943. One painting by Tobey and four by Graves were included in a survey that spanned the late eighteenth century to the present, proposing threads of continuity from Washington Allston's moonshot night scapes through Albert Ryder, to Feininger, Hartley, and Graves. Prominence was given to Graves, whose *Blind Bird* of 1940 was the catalogue's frontispiece (and one of its only two color plates) and whose work, compared to Ryder's and Klee's, was the concluding topic of Soby's catalogue essay. The perspective was a sensible one, but it has been almost entirely forgotten. That the Northwest painters in question looked at Asian art and looked into Asian philosophy is undoubtedly true. But where they looked from, why they chose to look, what they hoped to find — this has not been examined. Their own stance within their Western heritage, and within the troubled world of circa 1940, had a great deal to do with what they found when they looked to the East. They were part of a larger tradition in the modern West, a romantic tradition whose representatives since the eighteenth century had recurringly sought outside Europe's Greco-Roman heritage for an alternative to the increasingly restrictive rational mode of comprehending reality.

One more of Anderson's anecdotes makes clear the importance of this point of view. "I remember the time when Morris was interested in the *Bhagavad Gita*...so one Christmas we all got the *Bhagavad Gita* [as gifts from Graves]. Already, everybody had read it, but it was nice to have...so he met Ambrose [Patterson] on the street one day, and Ambrose thanked him for the book and said, 'You know, I had one of my own,' and he produced one out of his pocket that he had been carrying around for twenty years."[60] In other words, the book may have been deeply important to Patterson, but regarding it, evidently, from a different perspective he found its insights applicable in different ways from theirs to his life or art; and his sun-filled interpretations of momentary sensual and optical pleasure could hardly be more unlike their symbolizing and universalizing efforts. While the original proposal of Graves and Tobey as "romantics" was sensible within limits, it did have rather narrow limits. The term implied a certain independence and an introspection or possibly emotional turn, but it only suggested, without specifying, similarities to the structure and imagery of other artists. The intervening thirty-five years have taught us a great deal more about romanticism and about the artists

in question; and an examination of their works in this perspective now is illuminating in several respects. It suggests the particular meanings of their works; it clarifies their relationships to their contemporaries and to past traditions; and it illuminates the roles of nature, religion, mysticism, and the Orient, in their work.

Among many recent works on the subject, Robert Rosenblum's is perhaps the most provocative and useful for these particular issues.[24] Rosenblum argued for the strength and importance of a counter-current to the unbroken sequence of related stylistic problems and developments which, as exemplified most clearly in France, seem to form the backbone of art's evolution from the late eighteenth century to the present. This counter-current, he posited, is harder to characterize than the "main line" sequence because its appearance is one of visual and stylistic diversity rather than related continuities. But beneath the apparently wide diversities lies a commonality of concern for the transcendental in a world increasingly defined as secular and even as purely material. Most artists of this "northern romantic tradition" were concerned with, and often convinced of, the validity of intuitive and deeply personal knowledge as lying at the core of true comprehension. While academic neoclassicism and the positivist inclinations of nineteenth century realism and impressionism, all were concerned with the uniformly accessible nature of rational knowledge and its uniform applicability, the romantic respect for the intuitive and personal inevitably produced a greater diversity even among closely associated groups. Tolerance of idiosyncracies was far more basic than the development of doctrinaire "schools." This difference distinguished, for example, William Blake and his associates from Jacques Louis David and his followers; or, a century and a half later, was the basis for the abstract expressionists' insistence that there was no "New York School," and Callahan's assertion that there was not a "Northwest School." (Certain of the abstract expressionists interested Rosenblum a great deal, as carriers of the romanticism he described, and we can return to at least a brief consideration of them in comparison to the Northwest artists, whom he did not discuss.)

In spite of romanticism's privateness and resulting diversity, the shared concern for the transcendent and the repeated emphasis on intuitive methods led to the recurrence of a number of thematic, formal, and even physical characteristics. While not inevitable or defining

Kenneth Callahan
Rocks and People, 1945-1946

Tempera on gessoed panel, 22⅜ x 26⅛
Eugene Fuller Memorial Collection
Seattle Art Museum

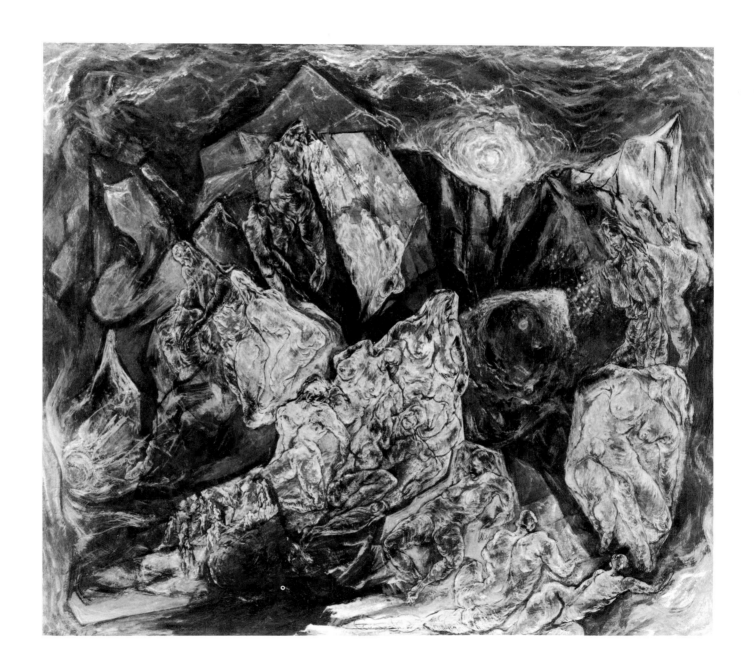

(unlike basically morphological stylistic definitions), Rosenblum thought these recurring qualities useful keys to many works' meanings. Different in nature from the sequence of formal problems successively tackled and solved by the "mainstream," these motifs and structures nevertheless give a certain visual coherence to the romantic tradition's varied individual inflections. So many of them can be recognized in works of Tobey, Graves, Anderson, and Callahan, that it is worth enumerating some of them together.

The yearning toward the transcendent frequently leads to the depiction of heavenly bodies as explicit or indirect symbols of the unearthly. Sometimes the stars but more frequently the radiant orb of sun or moon occur; and Rosenblum pointed out how often a circle is generalized so that either sun or moon might be implied. The fullness of radiant light itself is frequently depicted, a more disembodied symbol of energy than a sun or moon, and one whose radiance can seem to penetrate and dematerialize the material world it encounters. The stars and moons in Graves' works clearly participate in such a vision, and the same is true for some of Callahan's works. Tobey's "white writing" is preeminently "light writing," the vision of energies and rhythms disembodied from material confines and permeating both the space of objects and the space "between." This is clear from many of his statements and from his evolution of the technique-image out of the subject of city lights (*Broadway* e.g.). And it was clearly understood by Graves and Callahan in their adaptations of the technique — Graves using it to signify the concentrated energies ("aura," one wants to say) of any element — moon, rock, or bird; while Callahan employed it to unify the whole range of existence, inanimate, animate, and spiritual.

Graves' focus on one or a few beings is related to the deep devotion to nature that characterizes so much romantic art. Rosenblum pointed out that while responsive to the grandeur of nature, such ardent devotion has as often concentrated on a single, modest instance of natural form, seeing it as a microcosm containing by implication the whole of reality. Though we may associate such imagery with the nineteenth century romanticism of Blake and Wordsworth, it is at the heart of Klee's vision in the twentieth century, or of some of Marsden Hartley's work in America. While Graves' imagery most poignantly and explicitly embodies this insight, it also played a great role in Tobey's development. George Tsutakawa remembers that Tobey could talk for an hour about all the formal and material

aspects of a tea bowl or one flower as an example of the universe.[62] In a 1954 letter, Tobey attributed his attitude to an insight achieved twenty years earlier. "While in Japan sitting on the floor of a room and looking out over an intimate garden...I sensed that this small world almost under foot, shall I say, had a validity all its own...I suddenly felt that I had too long been exclusively above my boots." Ultimately the insight changed his art: "Subject matter has changed from the Middle West...to the most microscopic worlds. On pavements and the bark of trees I have sometimes found whole worlds."[52]

To sense the miniscule as an embodiment of the universe is one way of experiencing the unity of all existence. A common yet paradoxically opposite way has been to project one's mind toward the cataclysmic beginning or end of creation, towards the origin or the apocalypse in which all distinctions vanish and the singleness of existence appears. Such themes, drawn diversely from the Bible or from the prospect of modern warfare, or less violently from the synthesizing idea of an evolving universe and life, have haunted many romantic artists. An air of impending doom and dissolution hangs over many of Graves' creatures, but Callahan's work since the early forties involves the most explicit and persistent development of such a vision. Themes like the days of creation, visions of innumerable ethereal transluscent humans and horses intermingled with rocks and sky, alternate with studies of a single insect or small animal. He once described his theme as "Humanity evolving into and out of nature"[47] and later spoke of the "realization of the inter-relationship of rocks, planets, people, galaxies, protons, animals, ideas, plants." "Everything you examine in nature repeats this miraculous order."[61]

One other recurrent theme discussed by Rosenblum is also of interest regarding Tobey and Graves; that is the fascination with Gothic architecture, since the eighteenth century taken to be an almost unique instance of man-made transcendency. The notion that out of stone and, of course, glorious light, a deeply religious culture had produced an expression whose spirituality completely transcended its eminently skillful and materialist engineering — this notion appealed to generations of romantic artists, from the eighteenth century through Klee, Feininger, and Mondrian.

In 1949 Morris Graves spent several months in Chartres and painted a series of works inspired by the great cathedral, but he destroyed them all. A few years earlier, Tobey had explored the idea of Gothic

Kenneth Callahan
The Seventh Day, 1952-1953

Tempera on board, 24 x 32
39th Annual Exhibition of Northwest Artists Purchase Fund
Seattle Art Museum

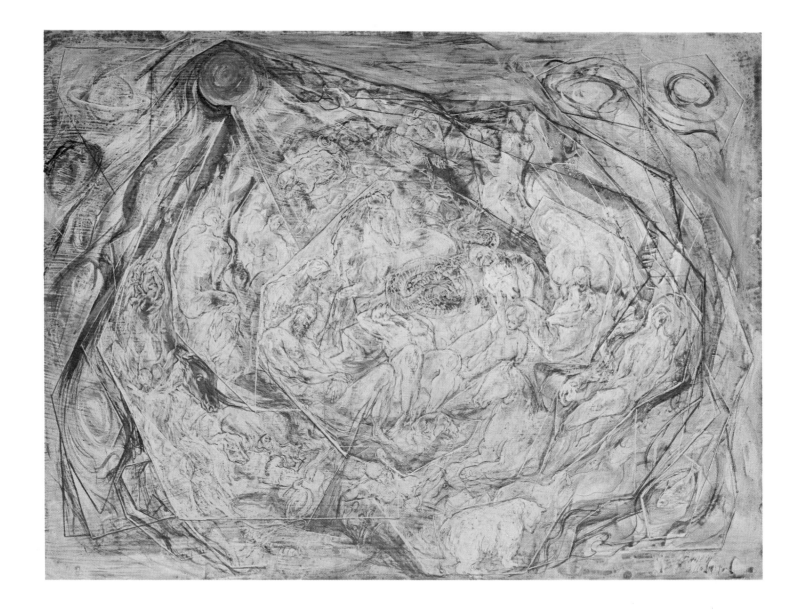

Mark Tobey
White Night, 1942

Tempera on cardboard on masonite, 22¼ x 14
Gift of Berthe Poncy Jacobson
Seattle Art Museum

disembodiment in several paintings crucial to the development of "white writing." In roughly the same years and for similar reasons he was fascinated by the modern city — that more recent cultural achievement in which mankind might be seen as having transcended materialism through its own technology. (Mondrian, too, in the same years of the late thirties and forties was fascinated by the modern metropolis.) Tobey, in fact, told an interviewer that his works inspired by modern life, including the series of cities, were romantic in their movement and formal composition.[44]

The repeated use of such motifs has been related, among many romantic artists, to an affinity for certain structural devices and even physical characteristics in their works, and here, too, the Northwest painters exhibit the same predilections. For example, an emblematic, simple focused and centered format recurs often, lending an isolated air as of a symbol to even very elusive motifs. A lone bird by Graves may provide the simplest example. But the late works of Anderson dominated often by a great circle or oval, and the delicate hovering fields of Tobey's white traceries loosely gathered into an elliptical or circular configuration, also evoke an emblematic centrality and simplicity. A vertical organization of a painting, implying an earthly and a transcendent realm often recurs too; among the Northwest painters one notices it particularly in Graves' creatures beneath moonlit or darkened heavens in his major works of around 1940, and much later in many of Anderson's paintings of the fifties and sixties. Rosenblum also cited a less frequent yet recurring interest in small scale works and non-oil media, and one can infer that these qualities particularly attract artists concerned with the universe in a microcosm. Only Anderson, of the four artists considered here, persistently used oil paint, and Tobey and Graves especially utilized a modest scale and water-based media in the crucial years from the late thirties into the fifties. (Tobey was later able to translate his vision and technique into a larger scale and into oil paint.)

These broad proposals, of themes and structures significant to many artists in two centuries of modern romanticism, help illuminate the significance of the same characteristics as they so often occur in the works of Tobey, Graves, Callahan, and Anderson. They also explain the deep affinity of these four for certain other artists who shared much the same vision. Blake, for example, of so much interest to Callahan; or Paul Klee and Albert Ryder, whose works enthralled them; or Marsden Hartley,

Lyonel Feininger, and Mark Rothko, all of deep interest to Tobey.

This perspective invites a closer look at the four artists individually. One wants to inquire about their intentions first, and the degree to which they were motivated, as Rosenblum would say by any concern for the transcendent, for the cosmic and universal — however personally and intuitively grasped. That nature provided abundant models in the Northwest is evident, and that Seattle's location and the Seattle Art Museum provided an unusual and sensitive approach to nature via Asian art is also true. But a fundamental condition of these artists' seeking the microcosm and the universe in nature was their reaction against World War II. Anderson said recently, recalling the war years, that he has always been a pacifist "and I couldn't possibly be anything else...So the only thing one could do was to work and help in the areas where it would be the least war-like."[63] Callahan, with a wife and family, was not drafted, but he worked summers as a one-man fire watch in the Cascade Mountains through several summers of the war. Tobey, born in 1890, need not have been concerned with serving in the front lines, but in addition his Bahai faith involved a commitment to pacifism. Recent research has made it clear that Tobey returned to the United States in 1938 convinced that upheavals and disaster would soon grip western Europe.[59] His sense of impending doom was reinforced and given weight by his Bahai faith, for as a friend of Tobey's (herself a Bahai) wrote in this connection, "the end of the world...the collapse of the old order...and the dramatic rise of the Promised Kingdom of God is the climate in which all Bahai live."[59] Graves registered as a conscientious objector and was, nevertheless, inducted because he was not a member of any recognized pacifist group; he was held eleven months before being released.

Their pacifist commitments and their horror of the world at war were significant factors in the direction their efforts took during the few years of intensified association and development about 1940. Anderson and Callahan have both recalled something of those initial efforts in recent interviews. At times, Anderson noted, they had talked about "all of the idioms and the isms that were being done...and all the various kinds of abstractions and all the various kinds of surrealism and where they stem from. And also collage...and the importance of drawing and the importance of experimentation and things like that."[63] But just before and during the war they wondered how their art could reflect in any

adequate way the world's state. Callahan's memory is that he, Tobey, and Graves, and occasionally Anderson, would meet at Callahan's house during the early part of the war and try to create symbols, bounded somehow by their own philosophies, which would allude to the world at war yet not be clichés. A few days later they might meet again, to criticize the work that had grown out of the earlier meeting.[61, 63, 64]

In his 1946 article, "Pacific Northwest," Callahan had given a similar account of the content of those talks. While it projects his personal views to a degree, it was closer in time to the events and undoubtedly reflected the group's views also, and is worth quoting at some length:

Over a period of some fourteen years they have mulled over such questions as the interrelation of man and nature, the infinite, Picasso and cubism, Chinese painting, and Oriental and Christian philosophies...Whereas these discussions first centered on ideas of machine dominance (the geometric world), the rise of fascism in Europe and Asia directed the artists' thoughts toward problems of humanity and its fate under political misdirection. As world conditions became increasingly complicated and war spread over the world, the Northwest artists began to question the old iron clad conceptions...They saw the world composed of people, not races or nationals, and found the various ancient philosophies and religions, including Christianity, based on essentially the same chart of moral laws...Simultaneously, scientific discoveries strengthened their sense of the world's unity. When the atom bomb exploded over Japan they saw nature reinstating supremacy over man...(and) that all men are equally controlled by and bound to universal laws of solar energy.[39]

These brainstorming sessions may be indirectly evident in the artists' works in certain instances. In the late thirties in Seattle, Tobey was apparently very involved with relatively overt symbolic usages based on the apocalypse and hermetic diagrams and signs.[59] One can hypothesize that the group's mutual criticisms and their consciousness of the danger of clichés "straightened him out" and sustained his pursuit of "white writing's" manifold possibilities. Graves had likewise made fairly explicit use of symbols in his 1938 drawings series, the *Nightfall Piece*. Each drawing satirized one of the countries at the Munich conference, with the image of a chair whose style, degree, and type of decrepitude alluded to the country. But he, too, drew back from anything so topical and localized to the more universally suggestive existence of his birds,

Mark Tobey
Forms Follow Man, 1941

Gouache on cardboard, 13⅝ x 24⅞
Eugene Fuller Memorial Collection
Seattle Art Museum

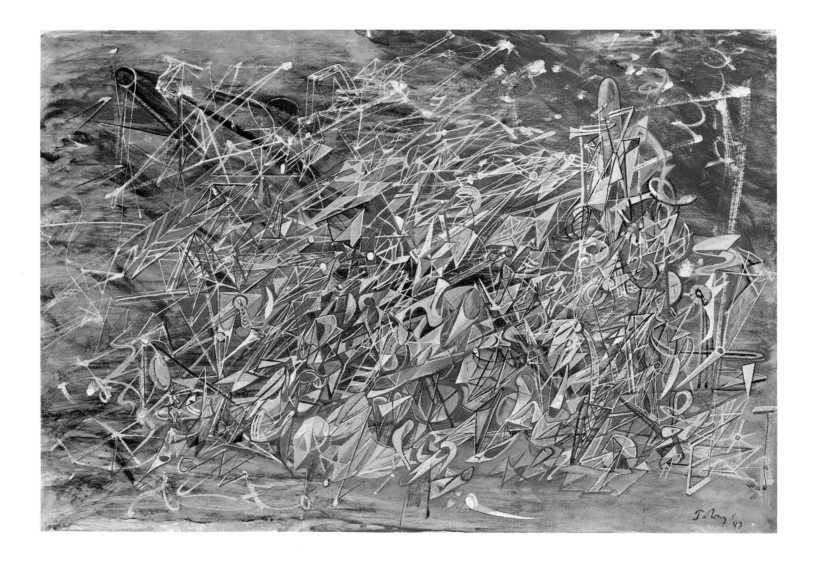

William Cumming
Two Loggers, 1944

Tempera on cardboard, 19⅜ x 11⅝
Music and Art Foundation Purchase Prize
32nd Annual Exhibition of Northwest Artists
Seattle Art Museum

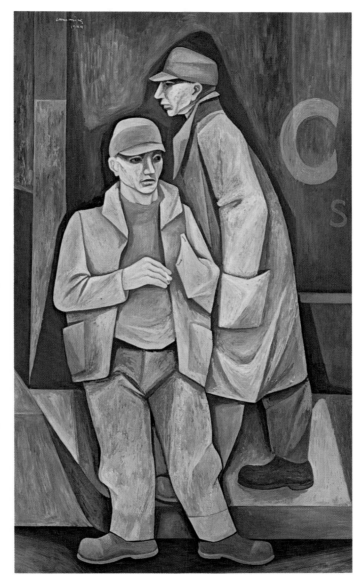

pine trees, seas, snakes, or constellations.

Both Tobey and Graves continued to embody in their works their deep concern for the world at war. But they achieved more simplified, abstracted, and even emblematic images. They relinquished visual and literary elaborations of meaning and retained only an essential core. Universal resonance thus overrode topical allusions. Among such instances one might cite Tobey's *Remote Field* of 1944, fragile floating bars in a field of scribbles and scratches, which he wrote contained "much more war, as it is felt, in it — more than all the reporting done by *Life* artists."[17] Graves painted a leaf series in 1944, "sear brown horizontal images ... meant as a commentary on the interminable war."[34] Likewise his 1945 drawing and painting of a gaunt, bedraggled *Bird Wearied by the Length of the Winter of 1944* was, he said, a comment on the duration of the war.[26] In a more personal vein, Graves' devastating army experience and eventual release had found a generalized expression in 1943, in a number of oppressively darkened bird images followed by the exuberance of the *Joyous Young Pine* series. But he hesitated even then to focus too narrowly on himself; and in a missive to Marian Willard of January, 1942, Graves drew a particularly poignant, even horrifying, skeletal bird bound Prometheus-like by its outspread wings to a rock, and chided himself at the same time by punning on his name. "Perhaps it's a crying fault to take oneself so gravely," he wrote under the image.[26] Later the same year, in his cryptic statement in the *Americans 1942* catalogue, Graves at least indicated a determination to transcend the personal — "I paint to evolve a changing language of symbols," to deal with "our mysterious capacities which direct us toward ultimate reality."[14]

The early war years evidently gave a purposeful urgency to the discussions of these pacifist artists. In a compelling aura of apocalyptic upheaval, their past readings and philosophic speculations were brought into sharp focus. Tobey's disturbing experience of England in the late thirties, Graves' experience in the army, and the ironic and tragic fates of friends and fellow artists who were Japanese-Americans, all reinforced the more universal air of disaster. It was this atmosphere, in part, that gave the artists the energy and the direction to rise above the explicit, individual or expressionist, towards personal perceptions of a universal world-state.

Through the long war and after, the urgency diminished, and the artists' developments took

Clayton S. Price
Horses in Landscape, ca. 1948

Oil on board, 15½ x 19½
Sidney and Anne Gerber Collection
Seattle Art Museum

Carl Morris
Mortal Shore, 1963-1964

Oil on canvas, 58 x 46
Eugene Fuller Memorial Collection
Seattle Art Museum

diverse directions. The basic modes of work and manners of expression which Tobey, Callahan, and Graves all brought to full development by the end of the war sustained them through the next decades. The exception to this, among the four, was Guy Anderson, whose work in retrospect seems clearly to have reached a much fuller development in the fifties. He is also an exception in that his sense of the world in crisis did not dissipate after the war, but persisted through the Cold War. Perhaps he found it hard to digest the idea that (as Callahan wrote in 1946) "when the atom bomb exploded...they saw nature reinstating supremacy over man."[39] Anderson recounted a conversation with the philosopher and esthetician Susanne Langer, with whom he was friends when she taught at the University of Washington in 1952-1953; and his account so succinctly evokes the sustained, repressed crisis of those years that it needs no further comment. They were looking into the flames in Anderson's fireplace one evening, "...and then she said, 'There is a possibility you know that the world will be destroyed by fire.' And I said, "Yes, I know, I know it's very possible." And she said, 'Well, how do you *know?*' And I said, "I've been taking the Bulletin of Atomic Scientists from the University of Chicago," and she said, 'Yes, well then you know.'"[60]

Morris Graves

Morris Graves was the first of the group to achieve national recognition, and there is perhaps some irony or paradox in this, as he was the youngest of the group. In fact, he was only thirty-two in 1942, when the inclusion of over thirty of his works in the New York exhibition "Americans 1942" brought him wide acclaim. Numerous sales and regular shows at Marian Willard's gallery followed immediately. The Phillips Collection in Washington, D.C., included him in a three-man show that year, and he was in the Whitney annual then and for the next twenty-five years. The next year, 1943, he had one-man shows in museums as far afield as Chicago, Minneapolis, Detroit, and Washington, and was included in at least four other museum's group shows. The suddenness and breadth of this enthusiasm combined with his relative youth did create a certain strain for him and for the group; and it formed a pole in one of many tensions, sustained and sometimes resolved, in the images of Graves himself and of his work. "I know it was difficult," Anderson recalled, "for Morris to be all of a sudden, you know, a kind of

Guy Anderson
Spring (Stop the Bomb), 1967

Newspaper collage and oil on paper on wood, 46½ x 30
Funded by a National Endowment for the Arts grant and
matched by the Pacific Northwest Arts Council
Seattle Art Museum

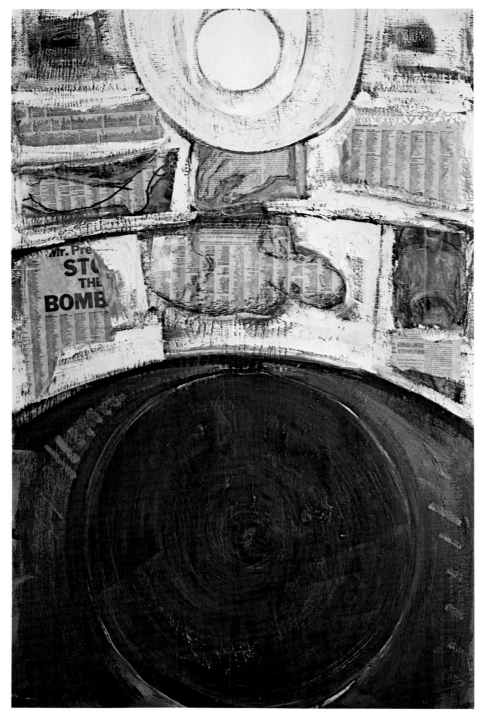

fair-haired boy of not only the Northwest but of New York and then soon other places."[63] Any potential image that might have formed of Graves as a brilliantly precocious and worldly professional was countered by casting him as an austerely withdrawn hermit of the Northwest woods. The image reinforced the deeply personal and often melancholy air of the bird paintings that had established his fame. The forthright simplicity with which Callahan had characterized him in a portrait of 1936 gave way to the more introspective and passive air of Imogen Cunningham's famous photograph of Graves, taken from an angle and from slightly above; the open sky behind him in the painting gave way to a close surround of rocks, mosses, and ferns. And the 1953 *Life* article which apotheosized the group gave less space to Graves' works than to a photograph of Graves himself brooding chin in hand among ferns and tree roots. *Life* described him as a "bearded recluse who lives alone" and who, when not painting, spent his time rather as a mad gnome might, "potting gnarled, dwarfed trees, pushing huge rocks into strange formations."[50] (His big feet and tennis shoes gave him away as the same real person Callahan had painted in 1936.)

Neither the successful young prodigy nor the austere recluse were images consistent with yet another aspect of the paradoxical aura Graves generated. Stories still surface occasionally in Seattle that cast Graves as an "enfant terrible," resident surrealist, and manic comedian; and a good number of them were finally set down in John Cage's poetic "Series re Morris Graves."[26] There one can find the stories, apocryphal or not, of his flamboyant gestures. Whether true or fantasied, the stories revealed certain patterns of how Graves was viewed. The earliest and most intimate recounted by Cage suggest a prankish good humor perfectly credible in an artistic ambience — e.g., that Cage and Graves lived in the same building and Graves put an end to an Irish tenor's 3am concert at Cage's when he "entered, carrying wooden birdcage, bottom of which was missing, plopped it over the tenor's head, said nothing, left the room." Cage said he met Graves (about 1936 or 1937) the day after a concert of Cage's music, which Graves had attended "with friends, a large bag of peanuts, and lorgnette with doll's eyes suspended in it. 'If he does anything upsetting, take him out.' After the slow movement, he said: Jesus in the Everywhere. That was taken as a signal."[26] That also, one may guess, set the tone of Cage's view of Graves. Other

Morris Graves
Bird Sensing the Essential Insanities, 1944

Tempera collage on paper on board, 26¾ x 53¼
Eugene Fuller Memorial Collection
Seattle Art Museum

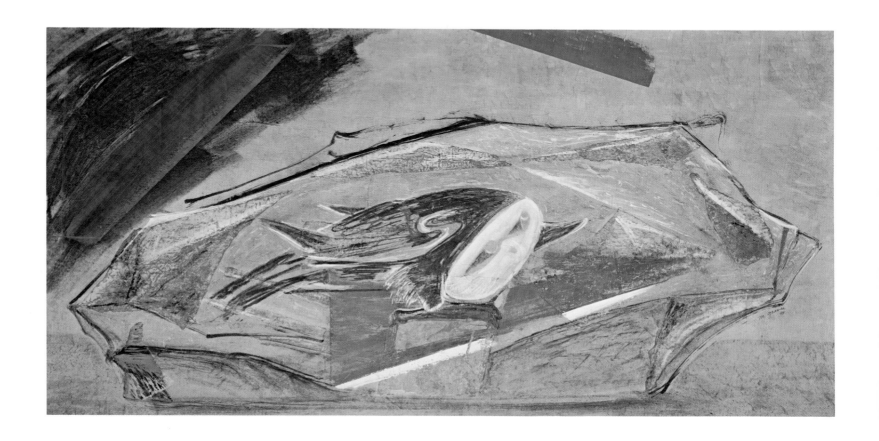

Morris Graves
Burial of the New Law, 1936

Oil on canvas, 43 x 38
Eugene Fuller Memorial Collection
Seattle Art Museum

anecdotes involved the general public — a red
carpet rolled from Graves' car to a luncheonette; a
baby carriage full of rocks and trailing strings and
tooth brushes, taken through the halls of Seattle's
most dignified hotel and arranged about Graves'
lunch table in the main dining room.

A number of the stories projected ambivalence
about privacy and publicity — stories of his
arranging a party for mostly museum officials, which
he himself refused to attend; of his inviting guests to
his house through a barrage of lawn sprinklers; or to
a house closed and locked, through the windows of
which the guests could see that a party had already
transpired. Indeed tensions between privacy and
publicness and between monastic austerity and
flamboyant sensuality seemed to underlay the
accounts of Graves' nest building and his travels,
like the accounts of more (anti?) social incidents.
His houses in the Northwest and in Ireland were
often characterized as refuges from the world, their
fences, eight-foot surrounding walls, and
remoteness were stressed. But inside, a hospitable
originality might appear, "He had removed all the
seats and chairs and put in a table and chairs so that the old
Ford was like a small furnished room. There were
books, a vase with fresh flowers, and so forth."[26] Or,
Cage suggested, a vision of a driftwood tree trunk in
a room, ice cream chairs in circle facing it, cawing
crows trained to remain on it. And were the walls of
his dwellings escetic or a sensual indulgence — the
Edmonds walls in the mid-fifties, of "the Graves
snuff color, faintly washed with white"[34] or the
rent-free walls Cage examined twenty years earlier?
"I paused to admire the charcoal walls, their sheen
and texture. He agreed they were beautiful. He said
there had been a fire."[26]

Cage suggested that Graves's character
ultimately transcended paradox. The poles
collapsed. "Sudden sense of identification, spirit of
comedy ... Ted said, 'The difference between you
[Graves] and them is that they are looking for
solutions; you don't think they're any problems.'"
Cage attributed to Graves a sentiment very like
Marcel Duchamp's epigrammatic "There isn't any
solution because there isn't any problem." "No
reason for you to drink: you're already drunk," Cage
added; and "He laughed in agreement."[26] Whether
Cage's assessment was correct, we may never
know unless, perhaps, Graves gives us an
elaborate last testament of some sort as Duchamp
did. For many years Graves has maintained a
rigorous seclusion (somewhat as Duchamp did)
that can be interpreted as either confirming or

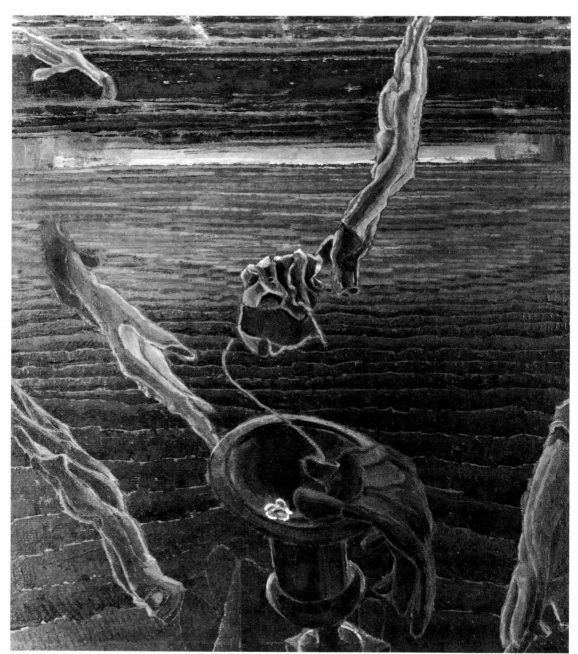

Morris Graves
Owl, 1943

Gouache on paper, 30½ x 26¾
Eugene Fuller Memorial Collection
Seattle Art Museum

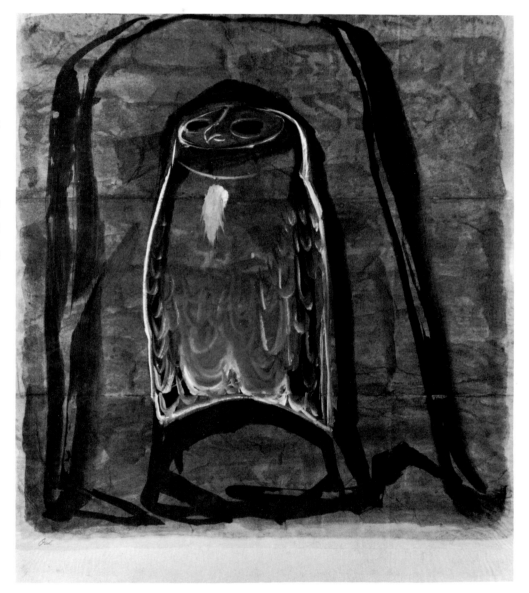

contrasting with the contradictory aura of his earlier career.

In Graves' art as in his life, his admirers were struck by tensions and paradox. Many relished his sensitivity to animal and bird life and emphasized his debt (dependency, some thought) to the Northwest forests and shores. But as he told Wight in the mid-fifties, "I am not so much a naturalist as some people suppose;"[34] and he told Katherine Kuh that records of experiences in nature inevitably seem limited compared to their source while "paintings of ideas continue to be ideas."[10] The importance of ideas and symbols was repeatedly stressed by Graves. Although his creatures were beautifully characterized and differentiated, this was the result of a symbolic empathy, not of naturalist observation. Like his simultaneously naturalistic and symbolic subjects, his works' simultaneously pictorial and decorative quality seemed a paradox to some. Graves was certainly aware that this was a difficulty for twentieth century Westerners and he occasionally tried to make distinctions helpful to viewers. Writing of his strong interest in Japanese painting in the early forties, he recalled that "it was the two dimensional quality rather than the decorative that appealed to me particularly."[26] But he refused to relinquish the refined splendor of Japanese materials and forms or to compromise them with the paint-and-canvas austerity of a European esthetic. He could note of a painting from the fifties, "This is painted on old Japanese Muromachi gold leaf taken from the tattered gold screens of the Muromachi Period and remounted under a very thin web of rice paper."[26] The possibility of transcending such seeming contradictions was exemplified perhaps by the oval black spot on the white ceiling, above the hearth of his Edmonds house.[34] Clearly it had a decorative aspect, related to the polished black and white marble of the chimney. But as clearly, it evoked the Western symbol of the eye of the deity and perhaps also the Eastern symbols of protection, signified by certain circular patterns on temples.[26] Yet another naturalistic evocation can be proposed; for in the house that preceded this one, Graves had been drawn to the hypnotic shimmer of a circular light pattern which a rain barrel outside cast on the ceiling when the door was open.[34] The decorative, the symbolic, and the observed; his personal history and pan-cultural traditions coalesced in the oval over the hearth.

In Graves' paintings, the tension between intense privacy and dramatic gesture that characterized his

Morris Graves
Concentrated Old Pine Top, 1944

Tempera on rice paper, 57½ x 31¼
Collection of Anne and John Hauberg

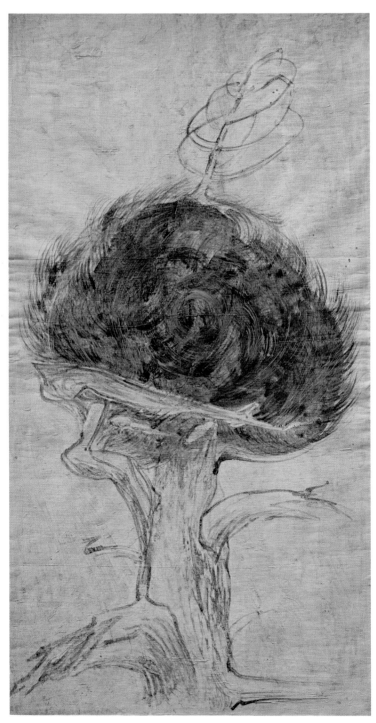

own image, was less a paradox or contradiction, than a great strength. Many of his best works were rooted in deeply personal emotions and simultaneously referred to world situations, and while their imagery appeared strikingly original, it drew deep wells of shared cultural heritage. They managed to walk a thin line between obscurantism on one hand and clichés on the other. Simplicity of composition, modest scale, and delicate handling gave them a candor which somehow reconciled private insight with public drama. Simply to enumerate, even partially, the many dimensions evoked by his best known birds helps clarify their rich synthesis of culturally accessible meanings with private meanings.

Grave's birds from the very late thirties and early forties were often creatures alone, beside the sea or in the moonlight. Some sang in the moonlight, some were blind or so drenched in the radiance of moon-shimmer that they must be "blinded by light," and many were named birds "of the inner eye." They were not in the traditions of ornithologists' observations, whether Audubon's or Asian painters', but more in the manner of Klee, Ryder, or Hartley. Simplifed and concentrated in rendering, they were creatures simultaneously winged like a spirit and vulnerable as any flesh (Ryder, Hartley, and Graves all depicted birds dead as well as living). Empathy for them established a bridge to the microcosm of physical nature and to the vast spaces they sought with wings. When pressed by Wight, Graves "remarked that the bird is a symbol of solitude, the shore, of the environment of childhood" —of being alone on the edge of space, the edge of the future, the edge of experience and understanding.[34]

The heavenly bodies of sun or moon, toward which Graves' birds yearned, were recurrent subjects among the romantic artists discussed by Rosenblum, from Blake, Palmer, and Friedrich in the early nineteenth century to Klee, Feininger, Marc (or Miro) a century later. Of course, Albert Ryder whom the Northwest group deeply admired was an outstanding example, and so was Washington Allston, included with Graves and Ryder as an important figure in the "Romantic Painting in America" exhibition. As Rosenblum made clear, the sun and moon were not merely devices of cheerful or moody ambience for such artists; they were positioned to become structurally iconic symbols of the cosmic or transcendent. They were sources of radiance and energy for earthbound creatures in indifferent or awestruck

Morris Graves
Sea, Fish, and Constellation, 1943

Tempera on paper, 19 x 53½
Gift of Mrs. Thomas D. Stimson
Seattle Art Museum

Morris Graves
Ceremonial Bronze Taking the Form of a Bird, 1947

Gouache on paper, 22 x 27½
Gift of Mrs. Fay F. Padelford and Mr. Philip S. Padelford
Seattle Art Museum

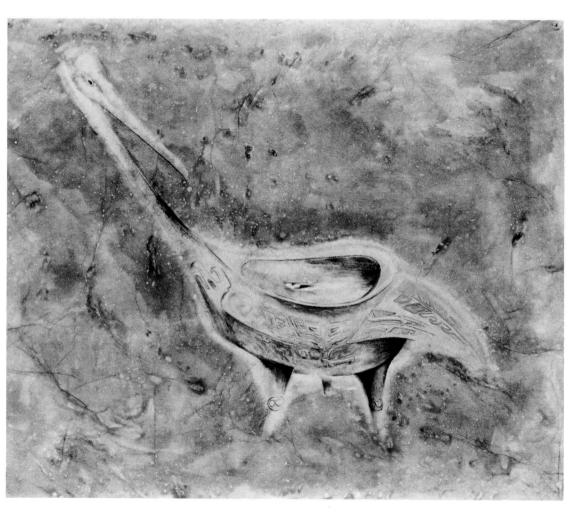

dependency. Callahan and Anderson stated in words as well as paintings, their sense of the world's singleness through its dependency on celestial forces. Graves invented the most explicit visual metaphor for the energizing and participatory relation of the microcosm to the universe in the tangled fall of moonlight upon a bird.

Light has long been the symbol not only of physical energy but of inner radiance, of "enlightenment." The organ that perceives light has likewise meant inner as well as outer vision. Graves' use of the eye that perceives, like his use of moonlight, resonated with the echoes of a rich romantic heritage. Nineteenth century visionaries and twentieth century surrealists sometimes treated the eye as an independent entity, free from the constraints of a supporting body, floating or soaring aloft (Redon, Grandville), hovering sun-like over the horizon (Klee), or window-like before an empty sky (Magritte). The eye as an independent sun and sensorium was evoked by Tobey's poem, repeated like an invocation in the movie about him from 1951-1952: "The eye burns gold burns crimson and fades to ash," and "where does the round moon live? . . . The eyes seeing remembered through other eyes."[58] The eyes of Graves' birds were a strongly expressive aspect of his characterizations, but their seeing was often complicated by mists, darkness, showers of moonlight, the constricting mineral oppression around the "birds of the inner eye," or blindness itself. The obstructions to sight expressed a great deal more than pathos or helplessness. Darkness, for example, could be threatening (as in the pre-war *Nightfall Piece*), but it also signified mystery, the edge of the unknown, and the necessity of looking within, particularly when combined with the ocean's edge as in *Burial of the New Law* from the thirties and so many of the birds. Picasso, in the prints from the thirties concerning the blind minotaur, had similarly combined night, blindness, and the shore in an evocative complexity. Blindness, as far back as the blind Homer and Oedipus, has been a metaphor for internal sight. Graves' birds sometimes gave specific inflections to that metaphor. With sight blocked, the abstract boundaries "seen" to define beings and objects disappeared, and a tactile commonality was established. For example, of a 1943 light-on-dark drawing, in which multiple versions of a single bird intermingled with rocks and waves, Graves commented that "We're walking through the stuff that we are."[26] The sense of being transparent to experience, and to space and matter, was akin to an

insight Tobey struggled through. It was also related to Graves' own sustained interest in birds and beings as vessels of consciousness. He tried to convey his sense that consciousness transcended the individual by using titles like *Consciousness Assuming the Form of a Crane,* or *The Individual State of the World.* He wrote in 1947 of "the bulked-up experience (psychic experience) of the human race" symbolized by a vessel. "Our own consciousness is the universe," he added.[45] Each fully conscious being then, might become a microcosm of the universe. In particular, Graves explored images of birds, ritual Chinese vessels, and minnows to suggest aspects of consciousness — its vitality, its focused containment, its elusive and multilayered nature. As the metaphors of blindness, night, and the sea suggested, full consciousness was not an ordinary or simple state. Graves quoted Coomaraswamy in his 1947 catalogue to try to make this clear. From the elements of sensible experience, art built something not judged by verisimilitude but "intended to convey an intelligible meaning, and beyond that to point the way to the realization in consciousness of a condition of being transcending even the images of thought."[45] Graves' explanations were intended to be more suggestive than definitive — as he told Katherine Kuh, he was wary of reading Jung because it might "interrupt his being a part of precisely what Jung is exploring."[10] Graves based his art not on intellectual formulations, but on an artist's sense of visual heritage combined with strong personal reactions to his own life and epoch. Thus he created deeply personal yet accessible imagery for a struggling and possibly transcendent consciousness.

Of the four artists, Graves' role in relation to the group about 1940 is the most difficult in some ways to penetrate. A genuine desire for privacy, and the screen of flamboyant humor and absurdity that viewers relished, make it particularly difficult to distinguish fact from fiction, and to decide whether a "fact" was a manifestation of Grave's basic character or a distraction and barrier protecting that character. Quite possibly, as the youngest, most restlessly dynamic, and then most acclaimed of the four, he was a continual stimulus and provocation to the others.

After a decade and a half of unrelenting inventiveness (from the 1938 *Nightfall* series to *Life*'s article about the four) Graves entered a period of withdrawal from those scenes and associates. He visited Ireland for an extended period, then returned to live there between wide-ranging travels, until he moved to northern California in the early sixties. In his works he castigated "machine age noise" in a series of drawings and paintings. They may have reflected somewhat the din of the naval air station that changed the ambience of his island home, or the hubbub of postwar growth that altered the surroundings of his Edmonds house. A series of hibernating animals suspended in the timeless self-sufficiency of perfect circles, projected his desire for retreat to an inner peace. Experiments with sumi ink and broad gestures also emphasized the privacy of experience — with "the intensity of a revelation" or "a smash which was a therapeutic release of some kind," as Graves wrote of 1952 and 1957 works.[26]

Graves' legacy from the fifteen years before his gradual departure included the image and anecdotes that still circulate (à la John Cage) and a body of work that still provides much of the context in which art exists in the Northwest. He had fulfilled the goal he articulated in 1942 — "I paint to evolve a changing language of symbols"[14] — with a richly varied sequence of works in series: Nightfall Piece, Purification Series, Message, Bird Singing in the Moonlight, Bird of the Inner Eye, chalices, vessels, pine trees, flowers, moons, snakes, circles, noises. More specifically, Graves' fascination with Chinese ritual vessels around 1947 might have stimulated Anderson's interest in the form-sense embodied in their surface configurations, so like the structuring of Anderson's later work. The metaphors he invented for inner sight, for consciousness itself, might have aided Tobey's more abstract explorations of the same issues; and Graves' particular imagery of eyes and spaces of thought seems to have contributed much indirectly to the verses (by Tobey himself) and imagery of the 1951 film about Tobey.

But the ramifications of Graves' art and of the group's in general, have yet to be really explored, and one example, their possible interrelations with a "Northwest School" of poetry serves as a good instance. This group of writers centered on the internationally known poet, Theodore Roethke, who was poet-in-residence at the University of Washington from 1947 until his death in 1963, and their activity continues to the present. Even more explicitly than the painters, they were often characterized as deeply drawn to the region's nature, as Wordsworthian and romantic, even as mystical. Connections between the poets' and painters' circles existed but to what extent and of what importance can only be guessed. In 1952, *Poetry* magazine published verse by several of

Paul Horiuchi
Genroku Era, 1960

Collage of mulberry paper with wash on board, 30⅛ x 48
Eugene Fuller Memorial Collection
Seattle Art Museum

Guy Anderson
Primitive Forms II, 1962

Oil on cardboard, 39½ x 29⅝
Eugene Fuller Memorial Collection
Seattle Art Museum

Roethke's students including Wesley Wehr, a friend
of the painters and later a painter himself. In the
winter of 1955-1956 a writer named Selden Rodman
arrived in Seattle wishing to interview Tobey, and
found it possible through the good graces of another
Roethke student, Carolyn Kizer, who owned several
Tobey paintings and knew him. Within a few months
Kizer introduced "Poetry: School of the Pacific
Northwest" to readers of the *New Republic,* with an
article whose first paragraph was devoted to Tobey
and Graves. Roethke himself was living then in the
Edmonds house that Graves had built so carefully
and abandoned for Ireland. A biographer noted that
the restless and anguished Roethke never felt
attached to any house before Graves', and in its
ambience he alluded, his wife thought, to Graves'
works in a poem, and even drew birds à la Graves.
Ultimately Graves offered to sell the house to the
Roethkes and only financial complications
prevented them from acquiring it. When they had to
leave the Edmonds house they stayed with Carolyn
Kizer while finding a place, then borrowed a rug
from another of the painters, Richard Gilkey, for the
unfurnished living room. A little later the Roethkes
visited Ireland where he became ill; and Graves
invited Roethke to visit and rest at his house there.[27]

Guy Anderson

The importance of Guy Anderson in this group
of artists was attested to by the others; and his later
work confirms that importance retroactively. The
nature of his contribution can be gleaned partly from
glimpses of his presence and his character in their
memories, and partly from certain paintings of the
forties and those later works in which his character
seems finally to have found a full expression.

Anderson himself modestly recalled *Life*
magazine's 1953 inclusion of him with the other
three, and at the same time suggested the fact and
the nature of their longstanding relationship:
Well, I thought it was quite interesting the way that
they [*Life*] sent out many people and then
criss-crossed from various other people interviewed
to find out what the painters thought of one another,
and what other people thought of them and who was
doing what, because I know that I was probably
number four in that group…And how it resolved
down to just four I never quite knew, except there
must have been some kinship there. I think part of it
is that…we were interested in symbolism and in
things that would, well, that were a little beyond
retinal art.[63]

Guy Anderson
Sharp Sea, ca. 1944

Oil on wood panel, 30 x 38
Margaret E. Fuller Purchase Prize
30th Annual Exhibition of Northwest Artists
Seattle Art Museum

Anderson was acquainted with Callahan and Tobey in the thirties, but he had an especially long and close friendship with Morris Graves, whom he had met in the late twenties soon after returning from his stay on the East Coast with a Tiffany grant. Both Anderson and Graves had roots in the small towns and valleys north of Seattle, to which both returned again and again through the fifties and, in Anderson's case, to the present. In 1933 Graves' family moved to Edmonds where Anderson lived, and the two began to work together a great deal. The next year they converted a Seattle stable into a studio for themselves, and then set off together on a wandering adventure in an old truck which served as home and studio and eventually took them to Los Angeles. By 1935 both were back in Edmonds, where Graves invited Anderson and two Chinese painters to celebrate his conversion of a bunkhouse to a studio, and where Graves and Anderson continued to sketch and work together. It was in 1935 also that Anderson began to visit regularly a much smaller village even further north, La Conner. That area soon attracted Graves also, who lived rent-free in a half-burnt La Conner house in 1938, and in 1940 he began to build his own shack and then a house on Fidalgo Island near La Conner.

At the end of the thirties the friendship of Anderson and Graves was supplemented by important additions: with Mark Tobey returned from Europe, Graves became very close to him and to Sherrill van Cott, while Anderson went to the Spokane Art Center and found a different stimulus in the cloistered and intense company of Carl and Hilda Morris and some New York artists working there, and Clyfford Still who was teaching in Pullman, Washington. Even then Anderson felt the lure of the newly forming Seattle group, and remembers how a borrowed Paul Klee painting hung on one side of his room and Mark Tobey's works on the other.[60]

Then followed the intensive two years of 1940 and 1941, when all four men were in the Seattle area, and the seminars and talks at Callahan's and Tobey's must have been most intense. After that, the pull toward the north and the wilderness, initiated by Anderson's early attraction to La Conner, was reinforced by Callahan's service as a fire watch in the summers and autumns of 1942-1944. He was stationed in Mt. Baker National Park, well north and on the slopes of the Cascade Mountains; and by 1946 he and his wife rented property in that direction near Granite Falls, where, for a couple of years, Anderson joined them for summers

Guy Anderson
Dry Country, 1955

Watercolor and pastel on cardboard, 30¼ x 40¼
Eugene Fuller Memorial Collection
Seattle Art Museum

of sketching and painting.

Tobey, of course, was unique among the four in sticking to the city except for visits to their country retreats; he concerned himself with the city's open market and as he said, could find the cosmos in pavement as well as in tree bark. And in fact, by the early fifties (about coincidental with *Life*'s apotheosis of the group) the mutualness of their concern with art and natural sites dissipated and they went their separate ways. Callahan traveled to visiting teaching positions as far away as California and Maine, and internationally with the U.S. Information Service exhibition that included works by the four, and he eventually moved well out of the Seattle region, southwest to the Washington coast. Graves drew back from La Conner to Edmonds again, then left to live in Ireland and eventually California. Tobey spent large amounts of time in Europe and eventually settled in Switzerland. Anderson, slowest to attain a satisfactorily sustaining style, was the only one to remain in the old haunts — he continued to work variously in Seattle, Edmonds, and La Conner for years until the mid-fifties, when the others were moving away and Anderson, in contrast, settled permanently in La Conner.

Even in this account of the group's geography, Anderson appears as a counter-balance, first pulling the group outward toward Spokane or La Conner and the countryside when their association was most urban and focused around Tobey's and Callahan's places in Seattle; then becoming most settled and loyal to the area when the others dispersed widely. In a deeper way, he was apparently also a counterbalance within the group through the direction of his interests and his judicious intellectualism. For while he shared deeply important attitudes and interests with them, Anderson did not hesitate to keep up a running battle with Graves over esthetic matters.

The pacifism that Anderson and the others were committed to through the crucial early war years has already been mentioned. Related to this, he was fascinated, as they were, by the religious and philosophic systems of non-European cultures, and sympathetic to the insights they offered as well as interested in their visual forms and symbols. "I remember not having difficulty with reading people like Coomaraswamy and then later on Joseph Campbell," Anderson said, emphasizing that for him there seemed no deep conflict between Eastern and Western approaches.[63] He was a person who read the *Bhagavad Gita,* the *Bulletin of Atomic*

Scientists, and the *New Yorker.*[22] The interest the group shared in non-European art was acquired early and deeply by Anderson. When he was only six his grade school teacher introduced him to Japanese prints, and his music teacher for ten years had a large collection of Asian art objects.[6] He was also impressed as a child by the Pacific Northwest Indian artifacts in the university's Natural History Museum. In the late forties or early fifties, Anderson and a few friends would go to a longhouse near La Conner to watch Northwest Indian tribal dancers — hypnotic and trancelike dances around fires. The group included Graves, Betty Willis whose help in bringing attention to Tobey's work was great, and Erna Gunther, an ethnographer who was well acquainted with many Indian groups, and a friend of hers, Eleanor King, who wanted to make dance interpretations of the ceremonies. Tobey accompanied Anderson in the forties and fifties to visit an Indian carver who they felt was one of the few left to work seriously. The carver came to believe their interest was genuine and would "tell us about his experience in getting his spirit."[63]

But these sympathies which Anderson shared with the others were always accompanied by a profound affinity for the European pictorial and sculptural tradition and a sharp awareness of Western parallels for the insights discoverable in Eastern cultures. One of his earliest interests was Greek sculpture, and he recalls carving soap when very young, and drawing with an aunt on winter evenings.[63] Anderson made a serious commitment to art early, and studied with a Seattle painter, Eustace Ziegler, who did everything possible to give his students a serious education — with life classes, outdoor sketching, and as much contact with art as could be obtained through his own collection of prints and reproductions. When Anderson went to the Tiffany Estate in the late twenties, his conventional training was continued and reinforced by the examples in New York museums. He was most deeply moved by artists of great expressiveness, who carefully controlled emphases by the placement and lighting of forms and the handling of pigment. Rembrandt, Goya, Turner, Ryder, and Whistler were among those who impressed Anderson most. Their principles have remained with him; in 1974 he wrote that "the all over timing of Pollock and Mondrian which gives equal stress to every area of the picture surface, doesn't interest me . . . Life is not equally timed."[6]

It was in this context that Anderson had what he called recurring "showdowns" with Graves over the question of pictorial versus decorative values.[60] In Anderson's view, Graves' interests were primarily interiors and furniture decoration. "So we used to talk about that a great deal . . . The importance of a painting, you know. Is it something more than to put on the wall, or fill a frame with?"[63] In contrast to the simplicity of a single item (*Moor Swan* or a wheelbarrow) Graves began to concern himself with more complex form and allusive symbolic suggestions after the mid-thirties, as in *Burial of the New Law* — preliminary explorations that laid the groundwork for his work about 1940. One can hypothesize that Anderson's arguments were an important factor in Graves' increasing sophistication.

If Anderson's respect for particular earlier artists seemed to imply a conservative visual emphasis on "pictorial values," such was not the case. In Spokane, only he and Hilda Morris encouraged abstraction. Anderson began then to experiment with materials and techniques that presented the strongest temptations to decorative or independently formal effects. He arranged rusty automobile parts and made collages out of similar material. "I still like," he said in 1974, "to use rusty cans, parts of iron and stuff that's almost gone, almost deteriorated to the place that there's no longer any mechanical relationship — it's almost gone back to the earth." At the same time he insisted that "I don't believe in the sort of decorative thing where the material and the surface do most of the work for you."[60] Back in Edmonds from Spokane, in the early forties, Anderson took on a similar challenge in working with driftwood. While he did not regard this as really creative,[60] he also insisted that there was "no cutesy stuff going on"[63] — no relish for the quaint as the word "driftwood" suggests to many, and also no cult of the object in the surrealist sense. Instead, the challenge was to completely reconcile the found item with the esthetic categories of the sculptural or pictorial, as appropriate.

Anderson's achievement in recent decades is the fruit of this long-sustained, uncompromising effort to incorporate the potentials of non-European art forms, of modern abstract form, and of the most diverse and assertive materials, without ever falling into effects that by Western esthetic criteria might be branded "merely decorative." In the best works of recent decades he has succeeded, creating paintings that are powerfully, unabashedly emblematic yet avoid the issue of decorativeness as almost no other large scale American work of the sixties and seventies has.

Anderson's loyalty to this Western heritage was sustained by his perceiving that tradition in the broadest way, and ultimately finding it capable of absorbing the lessons of Indian, Asian, and ancient cultures. His readings were in the same spirit. He recalls his youth as a time "when people read books" — whether Thucydides and the Great Books series or Louis Mumford and Faulkner. More related to the artists' own explorations, he says they all read William James. Anderson was drawn especially to certain authors of romantic and pantheistic inclination (Whitman has already been mentioned). "When I was quite young I was interested in people like Thoreau and Emerson and the transcendentalists."[63] One heritage from these writer-philosophers was a deep reverence for nature as the embodiment of the total — moral, esthetic, intellectual as well as physical — cosmos; and a sense of man as simultaneously dissolved into yet the seat of consciousness about the cosmos. As Rosenblum recognized, Emerson's immersion in nature was ecstatic — "I become a transparent eyeball; I am nothing; I see all; the currents of the Universal being circulate through me;"[24] and it anticipated Mark Tobey's long struggle (recounted in an anecdote about a fly in his studio) to assimilate his perception of space as multidirectional and unfocused, and of matter, including himself, as penetrable. The transcendentalists' insights are not unlike those to be gained from the pan-cultural investigations and Asian texts later pursued by the Northwest group, and with good reason: Emerson, Thoreau, and their friends avidly read translations of Hindu, Chinese, and Mohammedan texts, sometimes almost as soon as they were published.

This searching breadth and synthesizing assimilation were reflected in specific ways in Anderson's later works. Aspects which evoked a cosmic unity included his frequent use of great dominating circles, that might allude to the seed, the sun, the earth, or the cosmos itself. The cellular structure that he composed from circles and similar forms recalled, to many viewers, Northwest Coast Indian art; but in a typically universalizing way Anderson pointed out that they also related to Mayan and to early Chinese configurations.[63] The very structure of the works strained against the conventional pictorial tradition of the West; flattened, often starkly controlled by a vertical axis, emblematic, they had kin among the northern romantic artists discussed by Rosenblum, and

Guy Anderson
Deception Pass through Indian Country, 1959

Oil on paper on plywood, 11x30⅜
Sidney and Anne Gerber Collection
Seattle Art Museum

closer kin among medieval and non-European art.

Against these characteristics, certain indubitably Western traits persist. The human figure was seldom absent and seldom unimportant in Anderson's mature works, and his conception of the figure was clearly rooted in great European art. Sometimes a Blakean or Michelangelesque fullness characterized the figures, and many times also they were represented by simplified truncated torsos that clearly recalled the proportions and mass of classical sculptural fragments. The human forms were often participants in a basic structural dialogue that seemed, at the deepest level, to express an essentially Western dualism. Certainly Eastern philosophies have emphasized dualisms also, and Anderson's forms have been compared to symbols of Yin and Yang, for example. The difference was that, at least from a Western perspective, the Oriental view has been taken as emphasizing the interpenetration, reconciliation, and ultimate oneness of the duality. But whereas Callahan and Tobey, and frequently Graves also, seemed intent on embodying such a holistic vision in their works, Anderson seemed ultimately to define rather than transcend dualisms. The duality of male and female, to take an obvious instance, was basic to many of his works; so was a polarity of human anatomy on one hand set against stark geometry on the other. The dualities of light and dark and of heavens and earth were wider dualisms frequently embodied in his compositions. A fascination with points of passage from one state to another, or into and out of identity, was a fascination with the razor edge between the terms of a duality, not with the transcendence of duality. Even his titles reflected this somewhat—*Birth of Adam, Spring, Seed, Mouth of the River, Between Night and Morning.*

In retrospect, the germ of Anderson's development seems evident in a few works of the early forties and one can guess at the measured and complex contribution his presence made to the group then. In *Through Light, Through Water* of 1940,[6] a strongly abstracted world of sea, land, and figures in turmoil was dominated from above a high horizon by a stilled and iconic heaven: an orb of black in a red heaven, and another of gold against gold, which flanked a third central golden sphere suspended in an eye-shape. In *Whither Now Angel* of 1944 the division of upper and lower was repeated, and above the tumultous world appeared an early (large-eyed and somewhat frightened looking) predecessor of Anderson's much later horizontally floating figures.

Anderson's emerging dualisms seem to have been submerged for awhile around 1945, perhaps in an effort to follow the others of the group into a vision of dissolution and singleness. *Wounded Sky, Sharp Sea,* and *Against the Image* (1944 through 1946) exhibited strong swinging and looping linear rhythms as though to unify or at least embroil all elements. Yet in spite of the evanescence of subjects implied by the titles (sea, sky, image), the forms were oddly palpable, sharp edged, faceted, and aggressive. The titles too embodied aggression, as though unseen opposition was implicit in even the simplest unities. A more confident dualism reasserted itself by 1950 in *Search for Morning.* A figure very like that of *Whither Angel* dominated the upper register, but now with eyes concealed by a raised arm. The format had become vertical and the horizon line clearly defined so that the distinction of upper and lower was more prominent. A fallen horse below the horizon, taken with the figure above, suggested the moment of illumination when St. Paul was thrown from his horse, blinded by a great light. Perhaps significantly, in view of Anderson's love of reading, the only identifiable element to break the horizon and connect the two realms was an open book. While a number of landscapes from later years played down the dualism inherent in sky and earth or sea, it was still always present, and in Anderson's figurative and more iconic works the road from *Search for Morning* to the 1977 mural *Between Night and Morning* was unbroken.

Anderson's role in the group, one senses, was to sympathize with and understand deeply their mutual concerns and yet to resist also—to remain on edge there as in his philosophy. While the temptation has often been to call their attitude "mysticism," Anderson's would better be called mystical humanism. He has never relinquished an anthropocentric focus, and his sense of the tensions and polarities of mankind's existence have called forth a largeness of scale and proportions, a ceaseless energy, and weighty rhythms very different from the others' works.

Kenneth Callahan

Callahan, like Anderson, always had a basic concern for landscape and the human figure. From the early forties he set himself the goal of synthesizing these subjects to a holistic vision of cosmic unity, more directly and simply than Anderson could have accepted. In practical matters

Kenneth Callahan
Ebb and Flow, 1968

Oil and tempera on canvas, 40 x 84
Collection of Anne and John Hauberg

Kenneth Callahan
Mountain Landscape, 1951

Ink on paper, 21½ x 27
Eugene Fuller Memorial Collection
Seattle Art Museum

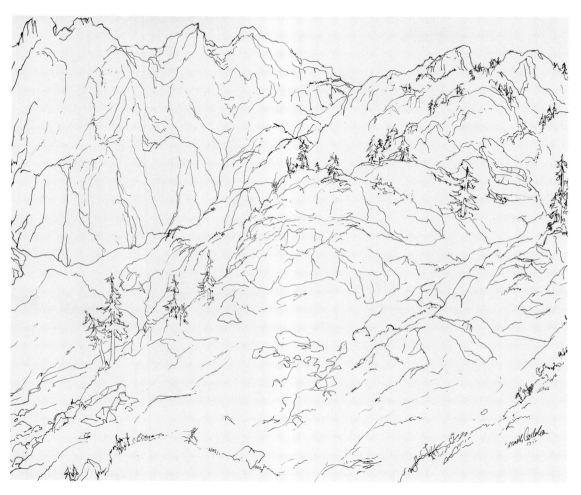

similarly, Callahan seemed to exemplify a direct and pragmatic approach to the world; and indeed he appears a bridge between day to day reality and nearly hermetic struggles that sometimes engaged the others. He was the only one of the four to marry and have a family, for example. (His son was born in 1938, when the group was drawing closest together.) His wife Margaret Bundy not only provided, apparently, occasional meals for the bachelors, but she was an active and important source of sympathetic support; she was editor of the *Town Crier,* and wrote for Seattle's larger newspapers about the city's artistic and literary activities. Callahan was the only one to hold a regular job through the years of the group's association (he was on the Seattle Art Museum staff part-time from the early thirties through 1953). The work not only provided him with a little steady income, it also put him in the position of being a bridge from the independent artists outside to the first rate Asian collections inside the museum. Through the same years, Callahan contributed articles on Seattle art to local and national publications, endeavoring to define as well as publicize developments in the Northwest.

While Callahan can be viewed as a kind of stabilizer or anchor for the group, no static or provincial narrowness was involved. Indeed he traveled as widely and enthusiastically as any of them. His involvement with the issues of his day shows in his art as well as his itineraries, particularly during the thirties when his dynamic compositions and heroic interpretation of mankind reflected his direct experience with Mexican artists and murals. A strong romanticism permeated all Callahan's work, modified in the thirties by expressive and social "realisms" and redirected in the forties toward a more personal and overtly romantic vein. Callahan's recollection of an early, moving experience of art is enlightening both for the delicately romantic artists to whom he was so drawn and for the sense of art's unique individuality that he drew from the experience. "When I was in San Francisco, about 1926, I saw for the first time the work of the "Blue Four"—Klee, Kandinsky, Feininger, and Jawlinsky ... I looked at these things, and all the next day I walked around thinking about them ... It was then I knew what I really wanted from art: to make an art that was mine, an individual, personal art that could come only from me. Good, bad, or indifferent, I knew I wanted but one thing, and that was to make my own paintings."[8, 61] His respect for these artists never diminished; and while he, Graves, Anderson,

Kenneth Callahan
Insect, 1966

Ink and tempera on paper, 22 x 28
Eugene Fuller Memorial Collection
Seattle Art Museum

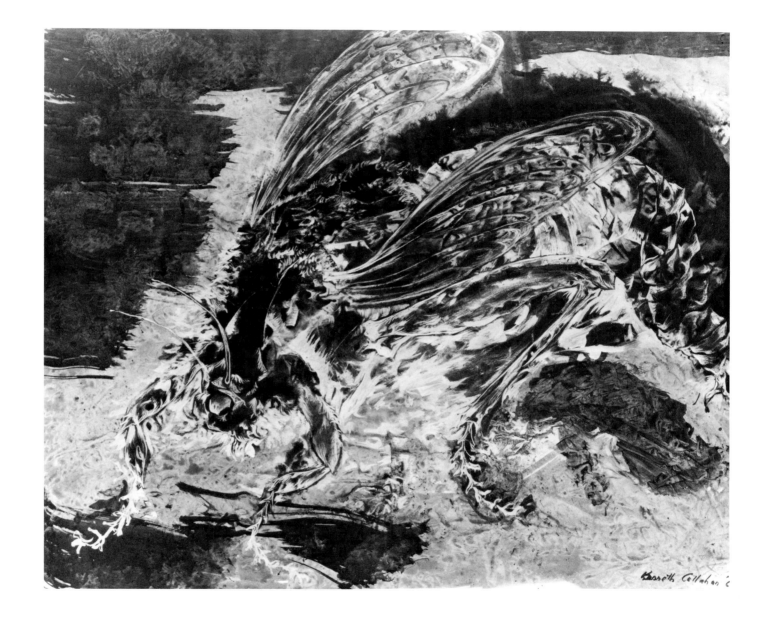

Kenneth Callahan
Northwest Landscape, 1934

Oil on board, 34 x 47
Eugene Fuller Memorial Collection
Seattle Art Museum

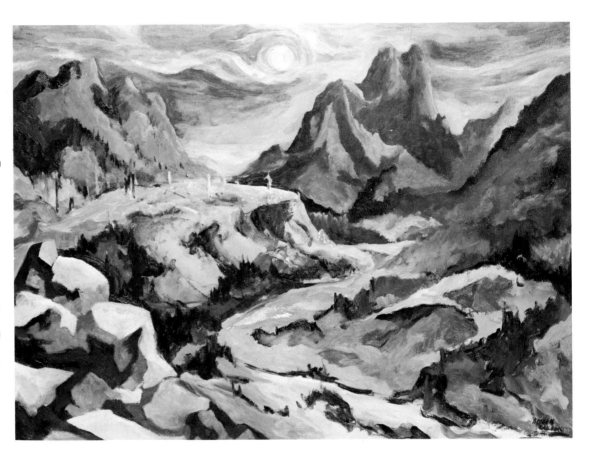

and Tobey viewed their own works as diverse and individual, Callahan remembers them as being in complete agreement discussing Klee, Feininger, and Kandinsky.[64] Ultimately Callahan's romanticism became broad enough to absorb even that epitome of classicism, the Elgin marbles, which impressed him deeply when he saw them in 1927 during a brief visit to London while in the merchant marine.[64] The Elgin marbles might have been among the precedents for the innumerable horses and mounted figures wending their ghostly ways through Callahan's later paintings.

Several other influences were assimilated before such a synthesizing vision was achieved. In 1930 Callahan and his wife went to Mexico for six months where they met a great many artists in an international atmosphere. They knew Orozco and Tamayo, met Rivera, and Callahan became better acquainted with Mark Tobey whom he had previously met in Seattle. Both Tobey and Callahan met Martha Graham and Marsden Hartley. Here Callahan was introduced to gouache which affected all his subsequent work. And here, of course, he saw the powerfully stylized "realism" of the Mexican muralists which so strongly influenced his work for the next decade. While Callahan traveled to Central America twice and to Europe once between his sojourn in Mexico and the war, it was a Mexican vision of humanity's grandeur and destiny that permeated his paintings. Lumberjacks, road builders, and sailors in merchant ships carried culture's mission into an inert or resisting nature. In spite of the physical massiveness and Cezannesque structure of his figures, Callahan's romanticism was implicit in their surroundings. Skewed perspectives, acid colors, and a startling irregular light-shot atmosphere filled many of the works. Toward the end of the decade, the figures diminished in scale or sometimes disappeared leaving the canvas to open out in vast moonlit mountain landscapes. The flickering light and shifting perspectives, unobstructed by human bulk or will, took on a pervasive rhythm that anticipated his later works. Romanticism was implicit in a different way in the ambitiousness of his immense *Lumbering in the Northwest* mural of 1933-1934 and in its interminably extendable nature (constructed of four-foot wide panels which could be added on indefinitely).

Callahan's development toward a more fluid and unifying manner incorporated something of El Greco's manner — an enthusiasm Callahan must have shared with Anderson. Callahan admired El

Kenneth Callahan
Riders on the Mountain, 1956

Oil on canvas, 21x35½
Eugene Fuller Memorial Collection
Seattle Art Museum

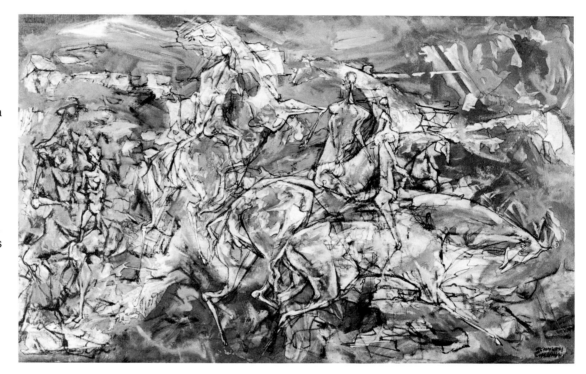

Greco ever since the late twenties, when his work in the merchant marine took him to New York. Callahan and Anderson were acquainted by the early thirties. Anderson shared Callahan's enthusiasms for Klee and for Greek sculpture, and sought out the El Greco paintings at the New York Hispanic Society on every visit to New York.[60] In his 1936 portrait of Morris Graves, Callahan combined a stunningly close and impassive figure with swinging curvilinear rhythms throughout figure and setting, in an expressive unity like El Greco's. Eventually even Callahan's horses and riders seem to have passed from the Parthenon through the landscape of El Greco's *St. Martin and the Beggar* and beyond.

This direction in Callahan's work was surely stimulated by the group's conversations in the very late thirties and early war years. He relinquished the representation of topical and contemporary subjects and searched with the others for symbols instead, symbols of the world's total state, not of its incidents. While Callahan's search was encouraged by the discussions, it was apparently confirmed by his deeply personal experience during the three seasons of 1942-1944 as a fire watch. As in other matters, Callahan was eminently down-to-earth and complete in achieving an immersion in nature. Alone with a store of food, a kerosene lantern, a supply of painting materials, and little to do on the job, he might pass two weeks without seeing another human being. The loneliness of the nights, the extremes of isolating fear and expansive belonging were his to relish. That he left a busy household perhaps made his impressions even sharper and his memories as he recounted the experience keener.[64] He dated the first of his genuinely symbolic works from those three years, and the basic philosophy behind them persists to the present. "The idea in general is the ancient and, to me, fascinating one of the interrelationship of man, rock, and elements; the creating and disintegration, repeated over and over: man into rock, rock into man, both controlled by sun and elements."[19]

Callahan's "idea in general" ultimately became a frankly religious attitude, not a secular philosophy (even though he spoke occasionally of the atom bomb or scientific concepts as confirming his attitude). Well before these years one other artist, eminently eccentric and romantic, came to appeal greatly to Callahan — William Blake. Similarities in form and subject can certainly be found, linking certain of Blake's and certain of Callahan's works. But more basic than this, Callahan was sympathetic

Mark Tobey
Self Portrait (detail), 1949

Pastel on paper on board, 20½ x 12
Gift of John L. Scott
Seattle Art Museum

to Blake's attitude toward religion, his unique and independent spirit toward religion in relation to art. As Callahan has suggested, the intellectual expression of Blake's philosophy may have been impossibly obtuse and convoluted, but in the visual works his approach to religion was an open and direct one.[64] Callahan tried to retain this openness in his ideas as well as his art.

Fascination with the perpetual cycle of creation-disintegration led Callahan to focus some of his works on the idea of beginnings, with titles like *Eve* or a series on the *Days of Creation.* The titles often indicated an unending mid-process, from *Revolving World* or *The Tides* in the forties to *Ebb and Flow* or *Rhythms* in the sixties. Like so many of the romantic artists characterized by Rosenblum, Callahan had a predilection for the extremes of macrocosm and microcosm as best embodying the perpetually renewed cycles. "Forms in nature from microcosm to macrocosm constitute an unending source of fascination for me."[19] Most often Callahan depicted immeasurable reaches of space, simultaneously earthly and cosmic. Occasionally (especially in the fifties) he turned to the other extreme, particularly to a focus on insects.

Ultimately Callahan struggled to see beyond the polarities of creation and disintegration, microcosm and macrocosm, human and rock. "Ideas fall apart and real disorder exists as it does today," he wrote in 1952, "whereas the orderly universe of truth is the simply incredible and wonderful order that exists when the universe as a whole is contemplated." Such a vision of the whole, revealing a "simply incredible and wonderful order" had been the goal of innumerable mystics in a religious context and romantics in an esthetic context. Its attainment had been the claim of relatively fewer. Callahan refrained from making that claim with a modesty characteristic of the others in the group. "It's the order I'm trying to find for myself," he continued, "— I know it exists and hope someday to fully experience it."[19] In 1972 Callahan accepted in a more permanent way the remoteness of a transcendent vision of the whole, and he seemed to imply that the effort to attain the vision was itself one of reality's perpetual cycles. "Buddha is supposed to have said," Callahan recounted, "that there are seven stages to Nirvana—and as soon as you realize that you've reached the third or fourth stage then you know that you have to go back to the beginning and start all over again."[8] To believe in the ultimate vision while accepting the prospect of never attaining it is to achieve a truly religious faith,

to "seek the sacred in a modern world of the secular" as Rosenblum concluded his account of other modern romantic artists. Since the forties Callahan's art has been, not so much the embodiment of a transcendent and holistic vision, as a symbol of its possibility. His paintings reiterated his faith in an order beyond the extremes he tried to reconcile.

Yet the paintings remained clotted with images of those extremes and the energies of attempted reconciliation. Particularly in the forties, the open periphery of the paintings sometimes contained moons, suns, planets or comets, around a vortex of luminous tangled matter. The vortex or vortices were often dominated by wraith-like forms of humans and rocks, exemplifying the poles of earthly existence and implying all intermediate forms. Drawn together by their dematerializing translucency and churning levitation, they seemed almost alike in nature and suggested the primordial origins of the universe. But if the subjects provoked a sense of evolution and primordial origin, the formal qualities often pointed toward an apocalyptic ending. A vertical organization (often a vertical format too) usually kept the suspended forms at a relatively uniform distance from the picture plane, however great the vastnesses behind them might seem to be. There they hung in a single great swirling unity or in agitated separate clusters; the precedents they recalled were the magnificent *Last Judgments* of Blake or Michelangelo. In the fifties Callahan's figures were often submerged in a more strongly abstract mode, and his forms were more angular and ragged. But the total sense of primordial and apocalyptic evolution persisted. Through the decades his colors persistently suggested a holocaust also: sooty umbers, chalky off-whites, acidic ochres and reds.

Even Callahan's working methods seemed to embody his sense of reality's perpetual renewal and dissolution in the most down-to-earth manner and with that directness characteristic of so much of Callahan's life. He painted in bursts of energy sustained for perhaps a week or several weeks, sometimes painting more than one work a day but not considering most of them really finished. At the end of such a period he might have thirty works of which one or two seemed satisfactory. He would put away a number of the others, and possibly return to some of them months or years later; and he usually destroyed at least half of what he had created.[64] The cataclysmic speed and concentration of creative spells, the suspension of most works in

Mark Tobey
Rising Orb (Bahai Series), 1935

Tempera over gold paint on cardboard, 9⅞ x 12⅞
Gift of Captain and Mrs. John E. Bowen
Seattle Art Museum

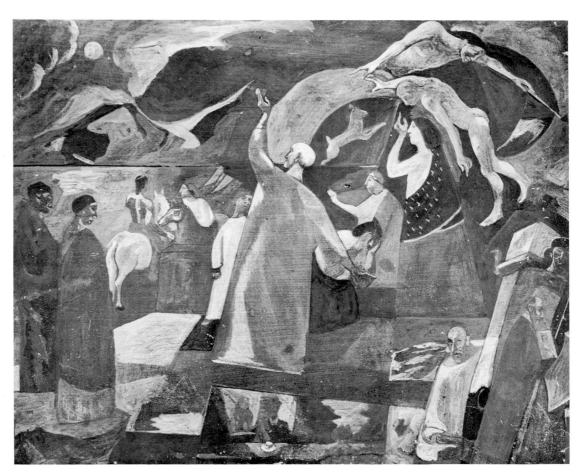

mid-process, the destruction of so many and acceptance of so few, all exemplified a romantic sense of nature's perpetual and dramatic flux. Or, in personal terms, the insight that when "you've reached the third or fourth stage then you know that you have to go back to the beginning."

Mark Tobey

Mark Tobey is recognized today as the most complex of the four artists, and the one whose work to date has spanned the longest time and the greatest diversity. Ultimately he achieved the widest recognition of the four. His relationship with Graves, Callahan, and Anderson helps clarify the pattern and significance of that long development, especially as it came to fruition in the years of his close association with them. Tobey shared Callahan's vision of the world's oneness, Anderson's sense of energy and of the Western cultural heritage, Graves' urgent yearning toward the transcendent, and the pacifist and pan-cultural sympathies of the others. The context of their work illuminated his own more abstract and subtly structured paintings.

Tobey was born fifteen years before the next oldest of the group, and his career was rooted in the decade of World War I rather than the postwar era. It began inauspiciously, with no real art training and a job in Chicago doing commercial fashion illustration. An anecdote set down in 1930 has it that Tobey plugged away at this until a fellow employee asked, "Why in hell don't you paint out of your own noodle?" The next Sunday he tried it, and the Sunday after that he left for New York.[46] To work from "your own noodle" came to mean something very different from using the faculty of imagination in the Western academic sense. As Tobey wrote years later of his working technique, "From time to time I have ideas. Sometimes I don't have any at all."[32] Something like the projection of a total state of consciousness, rather than of sensory perception or mental ideas, became his ultimate goal. But formulating the goal was difficult and realizing it even more so.

In his seventies, Tobey recalled how he had been bothered as a young artist in New York that "while art was discussed, liked, etc., that it appeared to have but small influence on the spiritual side of these people. I remember one night after an evening at a party at Marcel Duchamp's studio while waiting for an elevated train. I kept wondering if by chance there might be something else greater than

Mark Tobey
Signs and Messengers, 1967

Tempera on board, 39¾ x 28¾
Eugene Fuller Memorial Collection
Seattle Art Museum

art."[59] Like his host, Tobey sought an art that was more than "retinal." About this time, in 1918, he became a member of the Bahai faith. This relatively young religion, of Middle Eastern origin, had much in common with the theosophical beliefs that had drawn such widespread followings in Europe and America in the preceding couple of decades. It promulgated the basic oneness of the world's peoples and systems of belief and envisioned a new era of synthesis and unity to come. Tobey's conversion did not lure him away from art to "something else greater." Rather, like Mondrian and Kandinsky, who were both theosophists (and roughly twenty years older than Tobey), he sensed that a plastic art not based on "retinal" perception could be the ideal embodiment of transcendent insights. Mondrian's theosophical beliefs in a "world egg" and the unending dynamic equilibrium of the universe were imbedded in the diligently evolved formal vocabulary of his painting. Tobey's art too, came to focus on the all-pervading energy of a microcosm or a universe, but his sense of its dynamics was far more delicate and nuanced than Mondrian's balance of oppositions. Like Graves, Tobey construed a state of consciousness as a microcosm giving access to the world-state.

For roughly twenty years he worked toward a satisfactory expression, maintaining an uneasy relation with major forms of twentieth century modernism. Occasional works utilized the empty spaces and weird perspectives of a de Chirico-like surrealism; others the swinging rhythms of biomorphic surrealism (including his *Modal Tide,* focus of the "IS IT ART?" controversy Ross mentioned). More fundamentally, he made equivocal use of cubist vocabularies, the major basis of so many twentieth century forms and catalyst even to a radical romantic like Mondrian. Certain still lifes by Tobey in a Braque-like manner were elegant and splendidly satisfying works within the limits of that style, but Tobey never wholeheartedly accepted the style. Instead, as he related several times in the last decades of his life, he experienced in the early twenties an insight he called his "personal discovery of cubism." He was "in a room and there was a light," and imagining a drawing in his head he suddenly "began to think of a fly coming down here" and the fly's movements as unrestricted by gravity or logic, generating planes in the cube of the room. "And after awhile, I said, well, I can even go right through myself .. I can go right through that solid . . . I was freed from the cube."[59] The experience was rooted in his earlier desire to,

as he said, "smash form," and it ultimately found expression in aspects of his work such as the "moving focus" he often mentioned and the linear trajectories of white writing itself. This multidirectional and penetrable nature exemplified the synthesis of matter, space, and energy in a universal totality. Ultimately, of course, this vision transcended cubism and any Western formalist esthetic, but it was characterized in relation to them from the forties on; and late in his life Tobey described his insight via the fly with an air of embarrassed weariness, as though he expected listeners to find the account ridiculous and incomprehensible.[57] His sense of the misunderstandings with which a formalist and materialist epoch met less "retinal" interpretations of the cubist vocabulary was exemplified by his admiration for Duchamp's *Nude Descending the Staircase.* Fellow cubists had required Duchamp to remove it from an early group exhibition as somehow not conforming to the goals of cubism. As he wrote in 1945, Tobey was more confused than attracted by his sight of it in the 1913 Armory show, but deeply struck by it in Duchamp's studio a few years later, and ultimately it seemed to him "a Crucifixion."[59] In 1949 he defended it warmly as a great masterpiece, profound, and with "a great deal of cerebral substance."[28]

Withholding his commitment to either conventional or avant-garde modes, but unable to realize his own insights at once, Tobey searched far afield during those two decades. He studied calligraphy with a young Chinese artist in Seattle in the twenties and taught during most of the thirties in a progressive and experimental school in the English countryside. There he "awoke in a pastoral landscape" where "any American who stays long enough . . . will sense the mysticism that pervades the land."[56] From England he visited Mexico, meeting Martha Graham, Marsden Hartley, and Kenneth Callahan; visited Europe and Bahai shrines in Palestine; and visited China and Japan. In a Zen monastery, where he spent one month, he discovered the microcosm at his feet, and wondered about a sumi ink painting of a big, free brush circle he was given to meditate on. "What was it? Day after day I would look at it. Was it selflessness? Was it the Universe—where I could lose my identity?"[54] As he said of the earlier lessons in calligraphy, "Well, these things impressed me but . . . I didn't know how to use it. I'd experienced it but I couldn't use it."[59] Eventually Tobey succeeded through these researches in restructuring his sense of

Mark Tobey
Gothic, 1943

Tempera on board, 27¾ x 21⅝
Bequest of Berthe Poncy Jacobson
Seattle Art Museum

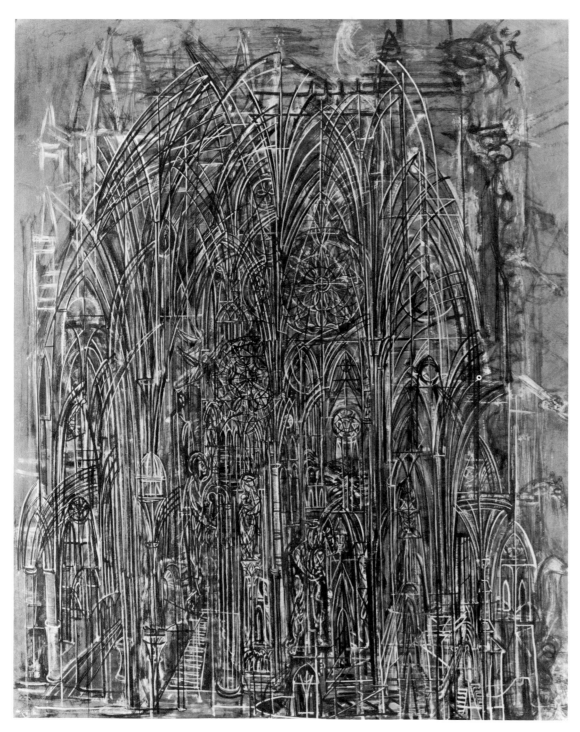

reality. In contrast to a romantic's awe before time's relentless flow and the immensities of space, he came to perceive a more transcendently romantic reality—hovering, multidimensional, simultaneous. His memories of his youth in Wisconsin were tied to the former. "The Mississippi, a mile wide and islanded in the center . . . flows through the nights— through the days . . . At night through the screen window the train on the Minnesota side looks like a child's toy . . . moving toward Winona." But in the Seattle environment that nurtured his art: "the windows are opaque with fog . . . I feel suspended— enveloped by a white silence."[56]

A synthesis of style and subject that could embody the new sense of reality still eluded him. As he tried cubist and surrealist manners occasionally, he also tried themes of great resonance—a series of animals in the moonlight after his trip to the Far East, for example, and "Bahai paintings" of rituals, heavenly bodies, and obscure symbolism. Two particular themes aided him especially in the crucial decade from 1935 to 1945; cities and Gothic architecture. Both were subjects in which he saw an overriding energy that dematerialized form; they provided a historical and a contemporary example of cultural constructs transcending the human and becoming universal. City rhythms appealed to Mondrian in the same way when he experienced London and New York in the forties, and they provided his paintings with a more precarious "dynamic equilibrium." John Marin and Reginald Marsh had already seen New York as a web of entangled light-fractured motion. Tobey's sense of the city was a synthesis of his experiences of New York and Shanghai, plus San Francisco and Seattle's agitated Farmer's Market. The synthesis was effectively set down with the beginnings of "white writing" in the pastoral quiet of England where "I could hear the horses breathing in the field"—a striking instance of the arch-romantic esthetic of poetry as taking "its origin from emotion recollected in tranquility."[10] The Gothic was a deeply fascinating subject to innumerable northern romantic artists from the eighteenth century on, as Rosenblum stressed. Klee, Feininger, Rothko, and Graves (among artists who interested Tobey a great deal) explored the subject. It was widely regarded as the preeminently "romantic" achievement of Western civilization, anti-classical and transcendent. More specifically, it was regarded by some Europeans as akin to Asian art in this respect; e.g., "Oriental art, which also arises from the need for deliverance, exhibits the same transcendental

Mark Tobey
Northwest Phantasy, 1953

Tempera on paper, 43 x 48¾
Collection of Anne and John Hauberg

Mark Tobey
Electric Night, 1944

Egg tempera on upsom board, 17½ x 13
Eugene Fuller Memorial Collection
Seattle Art Museum

character," as Wilhelm Worringer wrote in *Form in Gothic.*[36] Tobey read Worringer's work with great interest in 1935 (after his trip to the Far East), and in it found agreement with his own sense that the English mind possessed a dark and powerful vein of Gothic expression.[59]

With two decades of such experience and experiments, and with the urgency given by his sense of a coming apocalypse in Europe, Tobey returned in 1938 to Seattle to what Nancy Wilson Ross titled the "Farthest Reach," and what he himself described wryly as "the rainy shores of the Northwest where ... the Great Vacuum shifts and moans."[17] As Anderson characterized it, Tobey found there just enough people interested in him to sustain him in a friendly way, but not too much pressure and ambition.[60] In particular, a few fellow artists were in great sympathy with his general goals and concerned with related issues themselves. The group's association was mutually very stimulating for some years. Anderson recalled how much Tobey's high standards and sense of art's worth meant to the younger artists, and how they met for symposia, did warming up and loosening exercises with charcoal for example, and had picnics that focused on interest in painting.[63] Fifteen years later, the group had essentially dissolved, and without it Seattle wore thin for Tobey. In 1951 he bought two acres across the road from Graves' place, as a forlorn gesture toward permanence but without any real intention of leaving urban life. The next year he wrote to Marian Willard that "I can't paint here much longer. I never see Morris—Guy Anderson—they live too far away. There is no painting atmosphere at all." In 1953, "I am really marooned as far as the art world of Seattle is concerned ... Morris [Graves] came and we had an old fashioned day at his marvelous place."[17] By 1954, Tobey resumed his farflung travels.

Well before then, the years in Seattle had brought his insights into complete synthesis with his means of expression. Thematic concerns were not subordinated but absorbed into the "white writing" and related techniques. Anderson emphasized that Tobey used this language "in conjunction with his real religious sense" of history and mankind. "I think that there should maybe be more interest in that, instead of in what is the most exciting way of doing something or other."[63] His paintings' titles still suggested allusions embodied in the particular rhythms, densities, textures, and colors of each work: allusions to immensities of space, light, the *World Egg;* allusions to human constructs

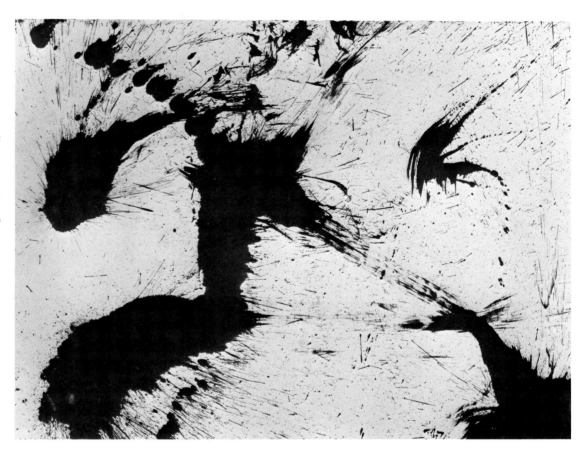

Mark Tobey
Space Ritual, No. 1, 1957

Sumi on paper, 21½ x 29¾
Eugene Fuller Memorial Collection
Seattle Art Museum

assimilated to the universal world state, as hieroglyphs, totemic forms, cities, "canal of cultures;" and allusions to nature's microcosms and seasons, as *Agate World* or *November Grass Rhythms.* He understood the context of seeking the cosmos in the miniscule, and the reverberations with which such seeking resounded. "I have borrowed from Leonardo's vision of life," he wrote; "I feel drawn to the leprous walls, drawn to bend down and pick up tin cans from American streets."[32] But again, he wrote "I got another big one which to date is called *Space Intangibles* ... Guess it's the most special thing I've ever painted and still remain romantic — for it is romantic and in the past century I would have called it *Magic Lake.*"[17]

As thematic aspects became totally assimilated to the visual form, identifying them verbally became less a literal and more a metaphoric matter. By 1946 Tobey felt sufficiently confident and versatile in his techniques to offer a few examples of the deeper meanings he sought. Of a particular painting he wrote that "the multiple space bounded by involved white lines symbolizes higher states of consciousness."[55] More generally, and significantly, he wrote the same year that "the earth has been round for some time now, but not in man's relations to man nor in the understanding of the arts of each as a part of that roundness. As usual we have occupied ourselves too much with the outer, the objective, at the expense of the inner world wherein true roundness lies."[15] The great majority of Tobey's "abstract" paintings contained a visual analog of inner and outer "roundness" in their visual form; their density decreased at the edge, and the concentrated central configurations might seem to fall back like a domed or hemispherical vortex or conversely, project forward. In either reading, it was the roundness of an organic complexity not a geometric abstraction — a roundness throbbing with "shifting focus" and "multiple spaces" and without the rigid distinctions of center or boundary. Clement Greenberg, William Seitz, and Dore Ashton were critics who made astute observations about this crucial aspect of Tobey's work, but ironically the most perceptive suggestions about its philosophical implications and context were reserved for French readers more accustomed to dealing with such matters.[38]

Ultimately the characterization of "higher states of consciousness" and of that "roundness" that is inner as well as outer was basic to Tobey's abstract-seeming paintings. There was no subject of these works, however vast and impersonal

Mark Tobey
Parnassus, 1963

Oil on canvas, 82⅛ x 47⅜
Virginia Wright Fund
Seattle Art Museum

or intimate and microcosmic, that was not simultaneously an instance of the infinite variety of inner "roundness." The essential microcosm was not the pattern of bark or the life of an insect, but an individual state of consciousness perceived as an instant of the world state. Friends who watched him paint—Morris Graves or George Tsutakawa—recalled Tobey's working state as a sustained, almost trance-like, and very draining effort.[23, 62] From the mid-forties Tobey gradually became more articulate about the importance of his actual state of mind in the creation of simultaneous form-content. "Don't know how much longer I can keep on whitewriting as it's too nervous a style—too exacting for a nervous man," he wrote Willard as early as 1947.[17] By 1954 he realized that "'writing' the painting . . . became a necessity. I often thought of my way of working as a performance in that it had to be achieved all at once or not at all."[52] In 1958 he specified the two strong characteristics of Japanese art that had impressed him a quarter-century earlier —its "concentration and consecration"—and his ultimate recognition that "a state of mind is the first preparation and from this the action [of painting] proceeds."[54] "I believe that painting should come through the avenues of meditation rather than the canals of action," he told Katherine Kuh in the sixties."[10] From saying in 1961, of his lessons in calligraphy, "I'd experienced it but I couldn't use it," he was finally able to specify in 1971 the aspects of Japanese art that were of use to him. "I did very much give my attention to this rhythmic power and its generation."[37]

In 1951, almost at the point of the Northwest group's dissolution, a film was made about Tobey which beautifully summarized his immediate sources and his uses of them. It also indirectly reflected the presence of the others while suggesting the quality of philosophical detachment that would lead them on their separate ways. The film, called *Mark Tobey: Artist,* was made by Robert Gardner, who, during a few years' residence in Seattle, also filmed the culture of Northwest Indians. Like the ethnographer that he was, Gardner followed Tobey from the intimacy of his studio and overgrown yard through the Seattle haunts that meant most to him—the backstairs and crowded aisles of the Public Market, the eccentricities of Seattle's peculiar bayside junk yards, the derelict castoffs of the gadget era waiting to be consumed by the void, (Tobey, 1942—*The Void Devouring the Gadget Era).* Sun-struck weeds and windows, and the neon light dematerialization of city streets at

night were included. Music composed by Tobey conveyed, even more than the occasional views of his paintings, his sustained rhythmic response to the subjects. The sequence of vignettes and the intersecting monologues of two voices over created an example of what has been called the poetic "trance film." This structure, characteristic of a number of American avant-garde films through the forties and early fifties, suggested the enigmatic inner journey of a protagonist towards some sort of self-realization and was appropriate, whether incidently or deliberately, to the sense of inner quest in Tobey's work.[7]

One voice reiterated lines of Tobey's own poetry. "The eye of the desert opens . . . it fades beyond in the fierce glow of sunset . . . The eye burns gold, burns crimson, and fades to ash" and "where does the round moon live? . . . The eyes are not related in unison. The circle is too small; it binds and bruises . . . thoughts can be round as the moon is round." The words related to recurring images of eyes and circles in the film — circles found or drawn, and eyes of people, of painted and sculpted head, of birds, eyes looking and eyes open to hollows beyond. Behind the images one could sometimes sense the birds of Graves or the delight in junk and in Indian art of Anderson. But the other projected an ironic distance, partly negative and related perhaps to Tobey's increasing detachment from Seattle, and partly perhaps related to the global point of view that had matured along with his art. "You'll be famous when you're dead but how is it now?" "Is this a garret? Where does the incense burn, where do the models undress?" "But you can tell more, Tobey; there's no mirror behind *your* eye."[58]

Clearly his global inclinations prevailed and Tobey wished to be a citizen of the world, not of any one site. His statement in the *14 Americans* catalogue of 1946 dealt entirely with the oneness of the world, "the need for the universalizing of the consciousness . . . unless we are to sink into a universal dark age," and the hope that the Pacific slopes of America might lead by understanding both Europe and the Orient.[15] He amplified his thoughts in 1948 in the avant-garde *The Tiger's Eye,* and alluded to them in 1949 as a participant in the "Western Roundtable on Modern Art," in San Francisco.

This three-day symposium of eleven participants included critics, historians, musicians, and three artists from the visual arts: Frank Lloyd Wright, Marcel Duchamp, and Tobey. In the thirty years since Tobey left Duchamp's party to wonder on the

Mark Tobey
Written Over the Plains, No. 2, 1959

Tempera on paper, 12½ x 9¾
Gift of the artist
Seattle Art Museum

El platform about the meaning of art, their careers had developed some significant parallels. Tobey was impressed with Wright as a sort of romantic anacronism. He wrote to Willard, "He has a spiritual force and I remember him . . . he is more rounded . . . still belongs to that unlimited organism called man." But Wright was "contradictory—prima donnaish— He said nothing that I agreed with really," and it was Duchamp's work that Tobey warmly defended.[17] Both Tobey and Duchamp had persistently sought the "more than retinal" in art; both had turned to words for aid, Duchamp through strange notes and Tobey through poetry. Both maintained pacifist and global positions important to them personally and to their art. And behind their universal sympathies lay, in each case, a history of each carefully keeping his distance from too restrictive entanglements with places, people, or institutions. Each undertook a mysterious early marriage; a situation from which he quickly extricated himself. Each left the provincial small town of his childhood for the cultural capital of his country and then took up a pattern of wandering between continents for long periods of residence, not just visits. Though neither was antisocial and each was the admired center, figurehead almost, of artistic circles sometimes, they both also chose self-imposed isolation and withdrew very definitely from intensely competitive scenes when they felt it necessary. Ultimately they both chose to spend their last years on their adoptive continents—Tobey moving to Switzerland and Duchamp becoming an American citizen. Perhaps appropriately, each was first accorded enthusiastic acclaim in art centers of his adoptive continent. The parallels extended only so far, for their works of course were very different; and Duchamp's pursuit of the more-than-retinal took an intellectual-skeptical direction while Tobey's might be called intellectual-spiritual. Yet even then, both artists sought to embody in art the mental energies that they believed best exemplified the nature of reality. Duchamp strove to be cerebral without being merely logical or rational, and Tobey to be spiritual without being merely occultist or mysterious. Both found it necessary to efface conventional limits of mind and achieve a broadened consciousness.

Throughout his life Tobey regularly turned back to representational work. In spite of the variety of subjects and manner, his greatest strength and most original insight were manifested in the "nervous" "white writing" that predominated through the last decades of his life. From miniature "meditation" pieces to large, almost environmental

Mark Tobey
Serpentine, 1955

Gouache and pencil on paper, 29¾ x 39½
Silver Anniversary Fund
Seattle Art Museum

works, his paintings bodied forth the nuances of states of consciousness, and invited reciprocal participation. Tobey recognized late in life that "I don't resemble anyone but have some kin to Klee;" yet his works also achieved something of the larger and more abstracted religiosity that Mark Rothko's late paintings did — Rothko, "the very best of all the boys in New York City" as Tobey thought.[17] Indeed Rothko's late work was Rosenblum's concluding example in his analysis of modern art's pursuit of romantic and transcendental goals. In a modern secular world, such concern with the transcendental has been no sure road to exaltation or even satisfaction, not even for those whose efforts were as moving and as acclaimed as Rothko's or Tobey's. Rothko committed suicide. Tobey manifested the greatest humility with regard to the success of his quest and the likelihood of its being understood by others. For years he had made it clear that he thought his understanding of Zen was limited, and that he had not experienced satori or enlightenment and thought few people had.[54] In interviews in the seventies he seemed impatient with questions about explicit Oriental aspects; perhaps because their simplistic assumptions belittled the years of effort and hard-won insights that lay behind his art.[37, 58] The Northwest group had, after all, read William James and they understood the difference between a conversion experience and a lifelong search. It was the latter that all of them to varying degrees exemplified in their work.

In imagery and structure then, works of the four artists often exhibited characteristics of a two-century tradition of European romanticism. These affinities helped clarify the works' meanings; they also helped explain the deep response the works elicited. In many ways, the four approached the problem of symbolism in art and searched for traces of "the sacred in a modern secular world" very much like their contemporaries in New York, with whom Rosenblum was deeply concerned in his account. Potential sympathies were suggested by occasional incidents; for example, the New York painter Theodore Stamos sought out Anderson, Callahan, and Tobey in the Northwest in the late forties. He visited their country places and traded paintings with Tobey, and shortly after met Graves at Chartres. The same sympathies ultimately led him into close friendship with the abstract expressionist Tobey admired most, and after Rothko's suicide Stamos was asked to oversee installation of Rothko's paintings in the Rothko Ecumenical Chapel in Houston. Given its emphasis on the

validity of individual experience and intuition, a romantic school is almost a contradiction in terms; and both the New York and Northwest groups persistently maintained that they were not a "school." In spite of the extremely varied and personal inflections within each group, however, broad differences certainly distinguished work in the two locales. Works of the Northwest group seemed to embody a humility and a tenuous optimism seldom present in New York. The frequently smaller scale and delicate media as well as particular imagery suggested these attitudes. The New Yorkers in contrast sometimes seemed like frontiersmen without, any longer, a frontier. Several were in fact from western states (Motherwell, Pollock, Still, e.g.). But the sense of the West in their work was of vast desolate mountains, deserts, and plains; very different from the pocketed complex of port city and nature that the Seattle area was for the others. The New Yorkers' work was often perceived as expressing desperation or violence. Its greater breadth of gesture required, very often, much larger formats and utilized heavier materials. It was emphatic, dramatic, even self-proclamatory. In spite of the underlying romanticism Rosenblum found in the works, their apparent break with tradition was radical, as though they felt the futility of pursuing either the closed and dead western frontier in the West or the broken and displaced traditions of war-torn Europe. One can speculate that the Northwest group's diligent search for syntheses was related to how they saw their historical position. In particular they all had a strong sense of the Orient as a tradition worthy of deep respect and, for some, of emulation. However modest their claims to understand it, and however little use they actually made of it, it exemplified for all of them a *potential* reservoir of insight and continuity. Indeed, the unmanageable immensity and diversity of Asian philosophies enabled one to feel that somewhere in them the right insights could be found. Western traditions, in this perspective, seemed less a trap than an alternative. The Northwest artists ultimately felt less threatened by older European art and more free to draw upon it than did their New York contemporaries. Enriching their art with culturally meaningful elements made it more directly accessible. It has been possible to understand their work without generating a whole new context of historical sequence and critical vocabulary (as was necessary for the New York painters).

Paradoxically, looking toward Eastern traditions in order to become free toward Western traditions is itself a Western tradition of the last 200 years. Its history closely parallels that of romantic painting characterized by Rosenblum, and for good reasons. Examining Oriental art and philosophies has gone hand in hand with romantic dissatisfaction at the increasingly restrictive rationality and logical bias of the West. The same rationality that caused such spiritual discontent also produced first the ships and navigational instruments and then the translations of texts that gave Westerners access to Eastern cultures. In particular, the variety and availability of translated Asian texts increased greatly from the late eighteenth century. Western romantics turned to them again and again, from Blake, so admired by Callahan, and the American transcendentalists, so admired by Anderson, through Mondrian, Kandinsky, and innumerable other twentieth century artists.

More particularly, in the twentieth century one can distinguish several waves of fascination with the Orient, and the Northwest painters' interests reflected the different emphases of those waves. From the 1880s or 1890s through the First World War, interest focused most on North African and Near Eastern sources and to some extent India also. Rosicrucianism and theosophy were perhaps the best known and most widespread developments of those interests, and directly involved numbers of artists. The Bahai sect shared characteristics with theosophy in particular, and appeared as a late development among these. By the decade before the Second World War, exploration of non-Western culture had incorporated numerous insights and attitudes from anthropology, ethnography, and Jungian psychology. In the thirties and forties, therefore, artists more often explored Far Eastern as well as Near Eastern sources and tribal as well as highly literate cultures. Surrealists led the way in much of this, and it was pushed much further by abstract expressionists and the Northwest group, for example, during the war years. In the decade after the war, a third wave of interest in non-Western philosophy and art arose, this time focused intensely on Japan and Zen. The culture that had seemed most demonically alien during the war also seemed afterwards (particularly when victimized by the atomic bomb and threatened with devastating Westernization) to be the last repository of profound insights denied by Western rationalism. The interest in Zen was perhaps strongest and earliest on the Pacific coast of the United States but it spread widely, including Europe. Ultimately it colored the European understanding of Tobey's work and, to

William Ivey
Wheatfield, 1967

Oil on canvas, 70¾ x 72
Collection of Anne and John Hauberg

William Ivey
Drawing, 1963

Oil on canvas, 60 x 71⅜
Eugene Fuller Memorial Collection
Seattle Art Museum

some extent, reception of work by the others of the group also.

Basically, however, Tobey spanned the first two of these surges of interest, from his adoption of Bahai in 1918 to the period of intense association with Graves, Anderson, and Callahan around 1940. His deep commitment and sensitive understanding of the issues involved were catalytic to his close associates in Seattle. They were freed by his example to reject the primacy of formal criteria or social realist concerns in art, and to accept their own more transcendental goals as valid. On the other hand, while his ardent Bahai faith and his search for universal expression were long-standing, Tobey had not, previous to his return to Seattle, felt satisfied with any artistic means of embodying that expression. The perspective he achieved in Seattle, through appropriate geographical distance from commercial and esthetic pressure and through the separate sympathetic insights of his colleagues, enabled the "white writing" of Tobey's city scenes to come to abstracted and independent maturity.

In the intense interaction of these four, in particular, lay the origin of that sense of "Northwest Traditions" which persists to the present. Their works were deeply qualified by their individual proclivities and by the attitudes they formed in response to a particular time and place. Nevertheless, they participated in currents that ran strong and deep through the last two centuries of Western culture. The quest for the transcendental or its traces allied them, even in their uniqueness, to many other masters of modern art. The "Northwest Tradition" that originated around 1940 eventually lent its strength to younger artists whose work could be recognized as embodying some similar qualities (Richard Gilkey, Philip McCracken, for example). It also drew further strength from later contributions. For example, George Tsutakawa and Paul Horiuchi, though significantly different in many ways, seemed by the power of their work and by their regard for their own Japanese traditions, to be vindications of much earlier work by Tobey, Graves, Anderson, and Callahan. The throbbing circles and mandalas of Leo Kenney likewise seemed to carry on the tradition, at the same time drawing it into that postwar fascination with Zen, to which his San Francisco years had perhaps given him intimate access. Like the larger romantic tradition in which it participates, the "Northwest Tradition's" vitality may surface in forms which are unexpected and at first unrecognizable. Its future is, far more than is the future of a "classic" tradition, necessarily obscure.∎

George Tsutakawa
Deep in My Memory, 1950

Oil on board, 21 x 21½
Collection of the artist

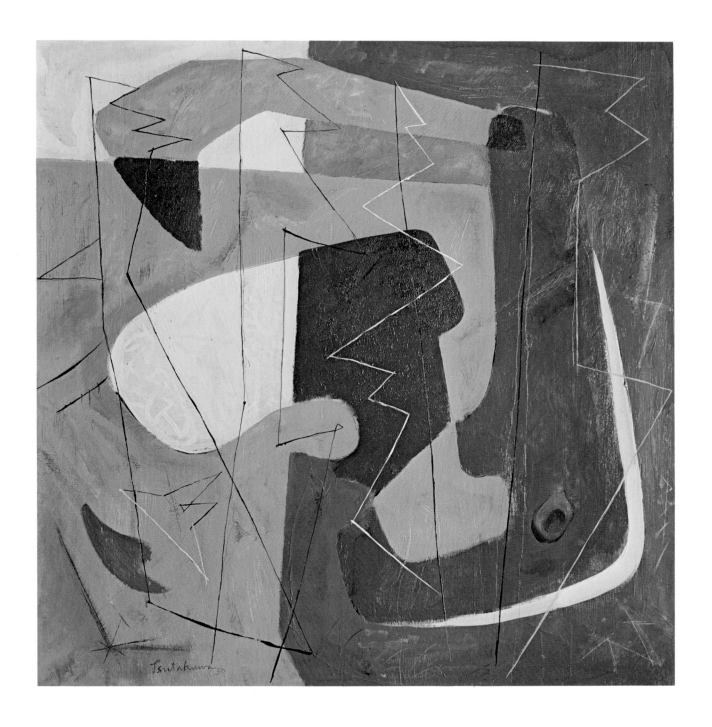

Bibliography

Books

[1]The American Abstract Artists, ed. *The World of Abstract Art.* New York: George Wittenborn, Inc., 1957. Includes "The Oriental Tradition and Abstract Art" by Charmion von Wiegand.

[2]Bass, Sophie Fry. *Pig-Tail Days in Old Seattle.* Portland: Metropolitan Press, 1937.

[3]Bridges, Ken. *American Mysticism from William James to Zen.* New York: Harper and Row, 1970.

[4]Christy, Arthur. *The Orient in American Transcendentalism.* New York: Octagon Books, 1969.

[5]Cornish, Nellie C. *Miss Aunt Nellie.* Seattle: University of Washington Press, 1964.

[6]*Guy Anderson.* Seattle: Seattle Art Museum and Henry Art Gallery, 1977. Includes essays by Wallace Baldinger and Tom Robbins.

[7]*A History of the American Avant-Garde Cinema.* New York: American Federation of the Arts, 1976.

[8]Johnson, Michael, ed. *Kenneth Callahan: Universal Voyage.* Seattle: University of Washington Press, 1973.

[9]Kingsbury, Martha. *Art of the Thirties, the Pacific Northwest.* Seattle: University of Washington Press, 1972.

[10]Kuh, Katherine. *The Artist's Voice.* New York: Harper and Row, 1962.

[11]*Leo Kenney.* Seattle: Seattle Art Museum, 1973. Includes essays by Tom Robbins and Leona Wood.

[12]Malkoff, Karl. *Theodore Roethke.* New York: Columbia University Press, 1966.

[13]Martz, William J. *The Achievement of Theodore Roethke.* Glenview, Illinois: Scott, Foresman and Co., 1966.

[14]Miller, Dorothy C., ed. *Americans 1942, 19 Artists from 9 States.* New York: Museum of Modern Art, 1942.

[15]Miller, Dorothy C., ed. *Fourteen Americans.* New York: Museum of Modern Art, 1946.

[16]Motherwell, Robert, ed. *Modern Artists in America.* New York: Wittenborn Schultz, 1951. Includes "Western Roundtable on Art," 1949.

[17]Musée des Arts Décoratifs. *Mark Tobey.* Paris: Musée des Arts Décoratifs, 1961. Includes "Excerpts from the Correspondence of Tobey to Marian Willard."

[18]National Collection of Fine Arts. *Art of the Pacific Northwest.* Washington, D.C.: Smithsonian Institution, 1974. Includes "Seattle and the Puget Sound" by Martha Kingsbury.

[19]*Paintings and Drawings by Kenneth Callahan.* New York: The Ram Press, 1960.

Articles

20 Parrinder, Geoffrey. *Mysticism in the World's Religions.* New York: Oxford University Press, 1976.

21 Pomery, Ralph. *Stamos.* New York: Harry Abrams, 1977.

22 Robbins, Tom. *Guy Anderson.* Seattle: Gear Works Press, 1965.

23 Rodman, Sheldon. *Conversations with Artists.* New York: Devin-Adair Co., 1957.

24 Rosenblum, Robert. *Modern Painting and the Northern Romantic Tradition, Friedrich to Rothko.* New York: Harper and Row, 1975.

25 Ross, Nancy Wilson. *Farthest Reach, Oregon and Washington.* New York: Alfred A. Knopf, 1941.

26 Rubin, Ida E., ed. *The Drawings of Morris Graves.* Boston: New York Graphic Society, 1974. Includes "Series re Morris Graves" by John Cage.

27 Seager, Allan. *The Glass House –The Life of Theodore Roethke.* New York: McGraw Hill, 1968.

28 Seitz, William. *Mark Tobey.* New York: Museum of Modern Art, 1962.

29 Sharpe, Eric J. *Comparative Religions, A History.* New York: Charles Scribner's Sons, 1975.

30 Soby, James Thrall, and Miller, Dorothy C. *Romantic Painting in America.* New York: Museum of Modern Art, 1943.

31 *Some Work of the Group of Twelve.* Seattle: Frank McCafferey at His Dogwood Press, 1937.

32 *Tobey.* Basel: Galerie Beyeler, 1966. Includes essay by John Russell.

33 *Tobey's 80, A Retrospective.* Seattle: Seattle Art Museum and University of Washington Press, 1970. Includes essay by Betty Bowen.

34 Wight, Frederick S. *Morris Graves.* Berkeley and Los Angeles: University of California Press, 1956.

35 *William Ivey.* Seattle: Seattle Art Museum, 1975. Includes essay by Virginia Wright.

36 Worringer, Wilhelm. *Form in Gothic.* New York: Schocken Books, 1964.

37 Yamada, Chisaburoh, ed. *Dialogue in Art, Japan and the West.* Tokyo, New York, San Francisco: Kodansha International Ltd., 1976. Includes interview with Mark Tobey and Chisaburoh Yamada.

38 Ashton, Dore. "Mark Tobey et la rondeur parfaite." *XXe Siècle,* May-June 1959.

39 Callahan, Kenneth. "Pacific Northwest." *Art News,* July 1946.

40 Callahan, Kenneth. "Ruminations." *Puget Soundings,* May 1965.

41 Callahan, Margaret. "Mark Tobey, Breaker of Art Traditions." *Seattle Times,* 17 March 1946.

42 Callahan, Margaret. "Movie Firm Grows in Seattle." *Seattle Times,* 30 December 1951.

43 Callahan, Margaret. "Seattle's 'Surrealist' Poet." *Seattle Times,* 16 March 1952.

44 Chevalier, Denys. "Tobey et les dangers de l'espace." *Chroniques du Jour,* February 1962.

45 Cohen, George Michael. "The Bird Paintings of Morris Graves." *College Art Journal,* Fall 1958.

46 Draper, Muriel. "Mark Tobey." *Creative Art,* October 1930.

47 Frost, Rosamund. "Callahan Interrelates Man and Nature." *Art News,* February 1946.

48 Kizer, Carolyn. "Poetry: School of the Pacific Northwest." *New Republic,* 16 July 1956.

49 Lee, Virginia. "An Interview with Guy Anderson." *Northwest Art, News and Views,* June-July 1970.

50 "Mystic Painters of the Northwest." *Life,* 28 September 1953.

51 Ross, Nancy Wilson. "What is Zen?" *Mademoiselle,* January 1958.

52 Tobey, Mark. (Excerpts from a letter.) *Art Institute of Chicago Quarterly,* 1 February 1955.

53 Tobey, Mark. (Excerpts from a letter.) *The Tiger's Eye,* 15 March 1948.

54 Tobey, Mark. "Japanese Traditions and American Art." *College Art Journal,* Fall 1958.

55 Tobey, Mark. *"Mark Tobey Writes of His Painting on the Cover." Art News,* 1-14 January 1946.

56 Tobey, Mark. "Reminiscence and Reverie." *Magazine of Art,* October 1951.

Miscellaneous

57 Gardner, Robert. *Mark Tobey Abroad.* Film, Phoenix Films, 1973.

58 Gardner, Robert. *Mark Tobey: Artist.* Film, Orbit Films, 1952.

59 Hoffman, Frederic Gordon. "The Art and Life of Mark Tobey: A Contribution Towards an Understanding of a Psychology of Consciousness." Ph.D. dissertation, University of California at Los Angeles, 1977.

60 Hoppe, William, and Wehr, Wesley. "Interview with Guy Anderson." 6 June 1974. Transcript available at Suzallo Library, University of Washington.

61 Johnson, Michael. "Interview with Kenneth Callahan." 1 April 1971. Notes available at Suzallo Library, University of Washington.

62 Kingsbury, Martha. "Interview with George Tsutakawa." 16 March 1978.

63 Svoboda, Patricia. "Interview with Guy Anderson." 18 March 1978. Tape and transcript possession of Patricia Svoboda.

64 Svoboda, Patricia. "Interview with Kenneth Callahan." 17 March 1978. Tape and notes possession of Patricia Svoboda.

Acknowledgements

The preparation of this essay was greatly facilitated by the research assistance of Patricia Svoboda. My thanks to her for her diligence and perception, and to the University of Washington whose Graduate School Research Funds supported her work. Thanks also to the numerous people who generously contributed their insights and memories in interviews and conversations, to Sarah Clark for her never-failing help with all manner of details, to Dr. Millard B. Rogers for reading the essay, and to Nancy Roberts and Sharon Krachunis for help in preparing the manuscript. Finally, thanks to David Munch and Margaret K. Munch who had to forego the pleasures of Northwest culture and nature in exchange for my writing about it.

Mark Tobey
Near Eastern Landscape, 1927

Gouache on paper, 11¼ x 16⅝
Eugene Fuller Memorial Collection
Seattle Art Museum

Morris Graves
Spring, 1950

Gouache on paper, 18½ x 13¼
Gift of Mrs. Prentice Bloedel
Seattle Art Museum

Louis Bunce
Work in Progress, 1964

Oil and pencil on canvas, 58 x 68
Gift of the Ford Foundation
Seattle Art Museum

Leo Kenney
The Inception of Magic, 1945

Egg tempera on masonite, 35½ x 23⅝
Eugene Fuller Memorial Collection
Seattle Art Museum

James Fitzgerald
Resurgent Sea, 1945

Oil and tempera on wood panel, 41 x 48
Eugene Fuller Memorial Collection
Seattle Art Museum

William Cumming
Abandoned Factory, 1941

Tempera on board, 9½ x 12⅝
Eugene Fuller Memorial Collection
Seattle Art Museum

Mark Tobey
Working Man, 1942

Gouache on board, 43½ x 27½
Eugene Fuller Memorial Collection
Seattle Art Museum

Leo Kenney
Camera Obscura, 1963

Gouache on paper, 27½ x 27½
Eugene Fuller Memorial Collection
Seattle Art Museum

Paul Horiuchi
Drums for Drama, 1966

Collage of mulberry paper on canvas, 51¾ x 42
Gift of Mr. and Mrs. Paul Horiuchi
Seattle Art Museum

Mark Tobey
Bars and Flails, 1944

Tempera and black pencil on fiber board, 22¼ x 16¼
Gift of Mr. and Mrs. A.S. Kerry
Seattle Art Museum

William Cumming
Worker Resting, 1941

Tempera on board, 14½ x 19⅜
Eugene Fuller Memorial Collection
Seattle Art Museum

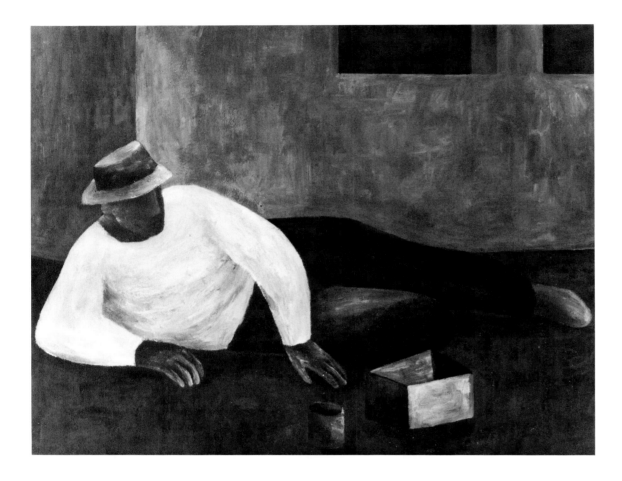

Richard Gilkey
Leek Still Life, ca. 1966

Oil on canvas, 32½ x 40½
Collection of Anne and John Hauberg

James Fitzgerald
Astroweb, 1962

Bronze with sandstone base, 10½ x 19¼ x 8¼
Gift of Seattle Art Museum Guild
Seattle Art Museum

Margaret Tomkins
Anamorphosis, 1944

Ink and egg tempera on gesso ground, 17⅜ x 21¾
Eugene Fuller Memorial Collection
Seattle Art Museum

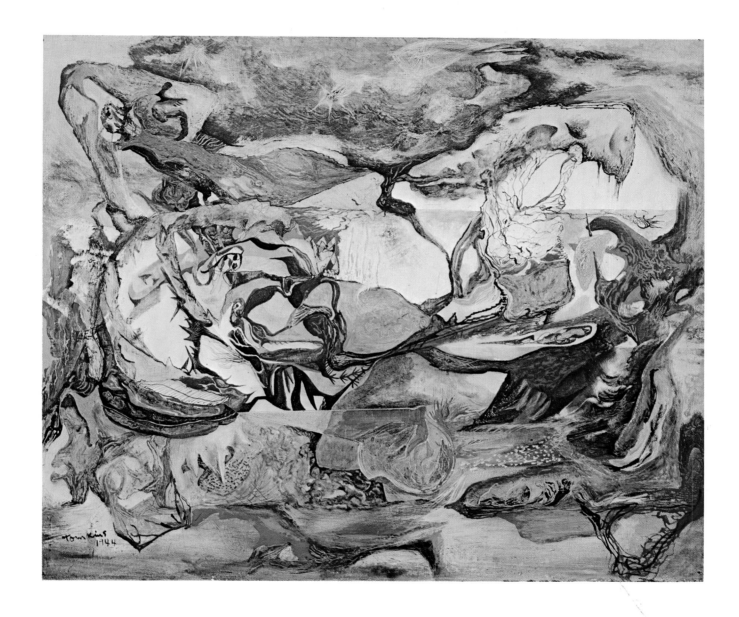

Margaret Tomkins
Night Passage, 1961

Oil on board, 12 x 23⅞
Eugene Fuller Memorial Collection
Seattle Art Museum

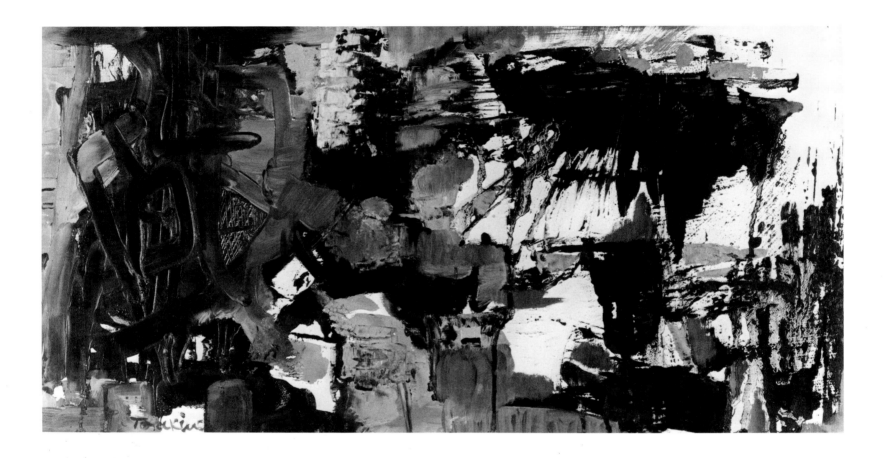

William Ivey
Landscape, 1961

Oil on canvas, 66¼ x 59¼
Gift of Gordon Woodside
Seattle Art Museum

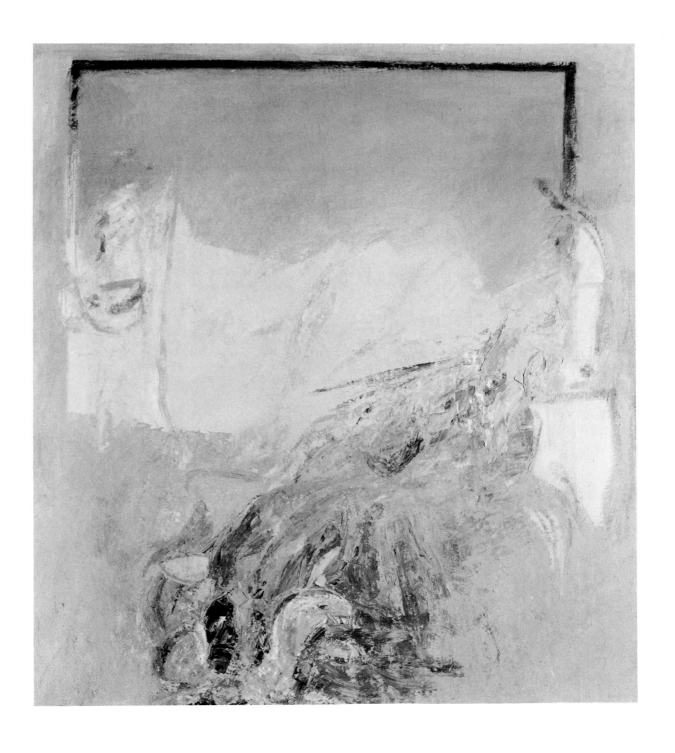

Carl Morris
Out of the Coulee, 1946

Oil on canvas, 26¼ x 36¼
Margaret E. Fuller Purchase Prize
32nd Annual Exhibition of Northwest Artists
Seattle Art Museum

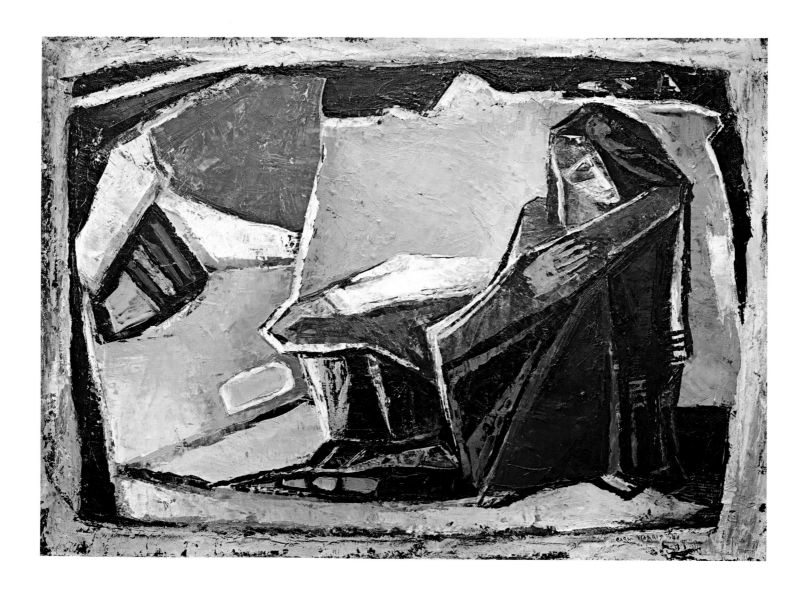

Mark Tobey
Skid Road (Skid Road Scavenger Series), 1948

Tempera on paper, 24⅝ x 18½
Gift of Joanna Eckstein
Seattle Art Museum

Richard Gilkey
Bridge, 1963

Oil on canvas, 23½ x 31½
Eugene Fuller Memorial Collection
Seattle Art Museum

George Tsutakawa
Mt. Walker, 1970

Sumi on mulberry paper, 20¼ x 36¾
Collection of Anne and John Hauberg

Mark Tobey
Moving Forms, 1930

Gouache on paper, 10¾ x 19½
Eugene Fuller Memorial Collection
Seattle Art Museum

Clayton S. Price
Boats, 1930s

Oil on board, 24½ x 30
Eugene Fuller Memorial Collection
Seattle Art Museum

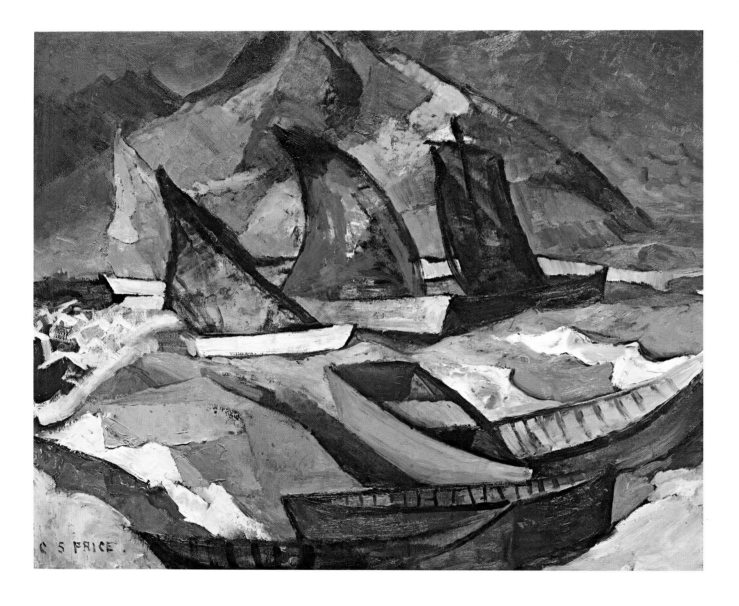

Biographies and Selected References

Guy Anderson

Born in Edmonds, Washington, 1906. Has lived most of his life in the Northwest except for a Tiffany Foundation Resident Scholarship on Long Island in 1929, and trips to California and Mexico in the 1930s. Studied privately with Eustace Paul Ziegler. Was on staff of Seattle Art Museum, 1933-1944. Had first major one-man exhibition at Seattle Art Museum, 1936, also 1945 and 1960. Has continued to exhibit regularly in Northwest, Los Angeles, and New York in early sixties. In late thirties accompanied Mark Tobey to Bahai meetings and accepted many tenets of Morris Graves' Zen Buddhism. Taught for WPA Federal Art Project at Spokane Art Center and exchanged views with Clyfford Still, 1939-1940. In late forties shared ranch and studio with Kenneth Callahan in Granite Falls, Washington. Toured Greece, Italy, and France, 1967. Major mural commissions in sixties and seventies include Seattle Opera House, Bank of California, Seattle, and Skagit Valley Courthouse, Mt. Vernon, Washington. Recipient of Guggenheim Fellowship, 1975. Major retrospective held at Seattle Art Museum and Henry Gallery, 1977. Represented in major museum collections throughout the United States. Since 1955 has lived in fishing village of La Conner, Washington.

1959

"At Seligman's." Anne G. Todd. *Seattle Times* 8 February.

"Painter Makes Area Live." John Voorhees. *Seattle Post-Intelligencer* 23 February.

1960

"Guy Anderson—An Artist Apart." Helyn Pierce. *Seattle Post-Intelligencer* 27 November.

1962

"Pacific Northwest." Henry J. Seldis. *Art in America* January-February.

1965

"Regional Accent: The Northwest." Wallace S. Baldinger. *Art in America* January-February.

"Guy Anderson Paintings Follow New Directions." Ann Faber. *Seattle Post-Intelligencer* 17 March.

Guy Anderson. Tom Robbins. Seattle: Gear Works Press.

1966

"The Artist at Bay." Rolf Stromberg. *Seattle Post-Intelligencer* 30 January.

1967

"Wherein Does the Magic Reside?" Guy Anderson. *Seattle Times* 23 April.

1974

Guy Anderson '74. Bellingham, Washington: Whatcom Museum of History and Art. Includes checklist with statements by Anderson and Cumming.

"Seattle and Puget Sound. " Martha Kingsbury. *Art of the Pacific Northwest.* Washington, D.C.: Smithsonian Institution, National Collection of Fine Arts.

1975

"Is It Guy Anderson's Turn to be Discovered?" R.M. Campbell. *Seattle Post-Intelligencer* 11 May.

"A Northwest Classic Exhibits." Deloris Tarzan. *Seattle Times* 11 May.

1977

"Seeing Through Guy Anderson's Mystic Screen." Steven Winn. *The Weekly* 29 June.

Guy Anderson. Seattle: Seattle Art Museum and Henry Gallery. Includes: "Guy Anderson: An Appreciation," William Ivey; "Guy Anderson: A Tribute," Tom Robbins; and "Guy Anderson: Comments on His Life and Art," Wallace S. Baldinger.

"Museums Pay Homage to Great Guy." Deloris Tarzan. *Seattle Times* 24 July.

"Guy Anderson, The Artist Who Stayed Home." R.M. Campbell. *Seattle Post-Intelligencer* 21 August.

"Guy Anderson's Double Retrospective." Matthew Kangas. *Artweek* 27 August.

Louis Bunce

Kenneth Callahan

museum collections throughout United States. Lives in Portland.

1955

A Retrospective Exhibition. Portland: Portland Art Museum. Includes Introduction by Thomas C. Colt, Jr., notes by Louis Bunce.

1966

"Bunce Show Pleasant and Warm, Despite 'Decadency,' Garbage." Anne Faber. *Seattle Post-Intelligencer* 18 February.

1967

Louis Bunce. Krannert Art Museum. Urbana: University of Illinois. Includes Foreword by Edward Betts, statement by Louis Bunce.

1973

Louis Bunce. Portland: Portland Art Museum.

1974

"Departure from Nature." Susan McAllister Brown. *Seattle Post-Intelligencer* 5 May.

"Portland and Its Environs." Rachel Griffin. *Art of the Pacific Northwest.* Washington, D.C.: Smithsonian Institution, National Collection of Fine Arts.

1975

"Louis Bunce, An Introspective Journey." Charles F. Gould. *The Oregonian* 19 January.

1978

"Bunce's Record of Radical Changes." R.M. Campbell. *Seattle Post-Intelligencer* 22 January.

"Forty Years of Louis Bunce." Matthew Kangas. *Northwest Arts* January.

Born in Lander, Wyoming, 1907. Moved to Portland, 1920. Studied at Portland Museum Art School, 1925-1926; and at Art Students League, New York, 1927-1930. Was assistant director and instructor for WPA Federal Art Project at Salem Art Center Association, Salem, Oregon 1937-1938. Participated in New York City Federal Art Project, Mural Division, 1940-1941. Returned to Portland in 1941. During World War II, 1942-1945, worked for Oregon Shipbuilding Corporation doing production illustration, tool design, and assembly. Had first one-man exhibition at Portland Art Museum in 1945, also 1947, 1956, and 1973. Has been given numerous one-man shows, including Santa Barbara Museum of Art, 1948; Museum of Modern Art, New York, 1950-1951; University of California, Berkeley, 1960; and Krannert Art Museum, University of Illinois, Urbana, 1967. Taught at Portland Museum Art School, 1945-1972. Awarded a Ford Foundation grant to work at Tamarind Lithography Workshop, 1961. In sixties, made three trips to Europe and was artist in residence at University of California, Berkeley; University of British Columbia, Vancouver; University of Washington, Seattle; University of Illinois, Urbana; and University of Oregon, Eugene. Was given a retrospective exhibition at Portland Art Museum, 1955. In 1978 was given a simultaneous retrospective exhibition at Gordon Woodside Gallery, Seattle, works from 1930-1950; and at Bellevue Art Museum, Bellevue, Washington, works from 1958-1978. Represented in major

Born in Spokane, Washington, 1905. Self-taught. First one-man show at Schwabacher-Frey Gallery, San Francisco, 1926. Went to sea as ship's steward and was given one-man show at Art Institute of Seattle, 1927. Wrote art news for *The Town Crier,* Seattle weekly, 1929. In 1933 was represented in first Whitney Biennial and joined staff of Seattle Art Museum as curator, continuing until 1953. Also in 1933 began writing about art for local and national periodicals, which continued over a period of fifteen years. In 1935 completed first mural for Weyerhaeuser Timber Company. Subsequent mural commissions include Washington State Library, Olympia, and Seattle Center Playhouse. Established studio in Granite Falls, Washington, 1937. Was given first major one-man show at San Francisco Museum of Art, 1939. In 1946 first one-man show in New York at American-British Art Center marked beginning of definitive style and attention from national press. In 1947 first one-man show at Maynard-Walker Gallery, New York, with subsequent shows in alternate years until 1965. Was given first one-man show in Europe at Galerie Georges, Brussels, 1948. Received Guggenheim Fellowship, 1954. In 1961, three-year national tour of thirty-four paintings and drawings from collection of Emily Winthrop Miles began. Fire destroyed collection and studio at Granite Falls, 1963. New home and studio established at Long Beach, Washington, 1964. Designed sets and costumes for *Macbeth* production of Seattle Repertory Theatre,

William Cumming

1972. Retrospective exhibition at Henry Gallery, University of Washington, Seattle, 1973, traveled to Portland Art Museum; and to Everson Museum of Art, Syracuse, New York. Major exhibition of paintings and drawings was held at Foster/White Gallery, Seattle, 1977. Has traveled extensively and has been visiting professor and artist-in-residence at major universities. Represented in major American museum collections. Lives in Long Beach.

1939

Modern Art in America. Martha Chandler Cheney. New York: McGraw-Hill Company.

1945

"In the Northwest." *Art Digest* 1 November.

1946

Kenneth Callahan. New York: American-British Art Center. Includes checklist with notes by Dr. Richard E. Fuller.

"Kenneth Callahan—Northwest Mystic." Judith Kaye Reed. *Art Digest* 15 February.

"Callahan Inter-Relates Man and Nature." Rosamund Frost. *Art News* February.

"Ken Callahan Surprises New York Art Experts." Alice Frein Johnson. *Seattle Times* 2 March.

"Pacific Northwest." Kenneth Callahan. *Art News* July.

"Museum Showing Callahan's Work." *Seattle Times* 18 November.

1947

"Kenneth Callahan." *Magazine of Art* April.

1951

Revolution and Tradition in Modern Art. John I.H. Baur. Cambridge: Harvard University Press.

1955

"Northwest Mystic." *Time* 3 October.

1960

Exhibition of Paintings and Drawings by Kenneth Callahan. New York: Ram Press.

1961

"Quiet, Exquisite Work by Kenneth Callahan." *New York Herald Tribune* 29 January.

"Major Show by Callahan to Tour United States." Ann Faber. *Seattle Post-Intelligencer* 29 January.

"Kenneth Callahan Show Opens at Woessner." Ann Faber. *Seattle Post-Intelligencer* 28 May.

"Callahan Sculptures Shown for First Time." Anne G. Todd. *Seattle Times* 11 June.

"Callahan—Portrait of the Artist as Contemplative Man." Anne G. Todd. *Seattle Times* 8 April.

1962

"Pacific Northwest." Henry J. Seldis. *Art in America* January-February.

Art USA Now. Lee Nordness. Lucerne, Switzerland: C.J. Bucher, Ltd.

1963

"The Great Olympia Mural Controversy." Tom Robbins. *Seattle Times* 24 March.

1965

"Ruminations." Kenneth Callahan. *Puget Soundings* May.

American Painting in the 20th Century. Henry Geldzahler. New York: Metropolitan Museum of Art.

1967

"Callahan's Island in Time." Jim Faber. *Seattle Post-Intelligencer* 29 October.

1973

Kenneth Callahan: Universal Voyage. Henry Gallery. Seattle: University of Washington Press. Includes Introduction by James Harithas, notes by Kenneth Callahan.

"Callahan's 'Universal Voyage' at Henry Gallery." Deloris Tarzan. *Seattle Times* 1 April.

"A Conversation with Kenneth Callahan." Joan Mann. *The Arts* April.

1974

"Seattle and Puget Sound." Martha Kingsbury. *Art of the Pacific Northwest.* Washington, D.C.: Smithsonian Institution, National Collection of Fine Arts.

1976

"The New Dimension of Kenneth Callahan." R.M. Campbell. *Seattle Post-Intelligencer* 23 January.

1977

"The Artist on 'Public Art'." Mary Ellen Benson. *Northwest Arts* 24 June.

"A Joyous Display by Ken Callahan." Deloris Tarzan. *Seattle Times* 30 September.

"New Excitement from Grand Old Callahan." Robert C. Arnold. *Argus* 30 September.

Born in Kalispell, Montana, 1917. Grew up in Tukwila, Washington. Self-taught. Intrigued by figures in action found in western scenes of Charles Russell and Tanagra figurines. Began professional career on WPA Federal Art Project in Seattle, 1938-1940. First one-man exhibition at Seattle Art Museum, 1941. Forced to give up painting because of ill health in late forties and early fifties, but continued drawing and studying Renaissance and Baroque masters. Major one-man exhibition held at Seattle Art Museum, 1961. Subsequent one-man exhibitions include University Unitarian Church, 1963; Scott Galleries, 1964; Gordon Woodside Gallery, 1965, 1967, 1968; and Polly Friedlander Gallery, 1973, 1975. Has taught at Burnley School of Allied Arts since 1953, and Cornish School of Allied Arts since 1962. Lives on ranch near Issaquah, Washington.

William Cumming (continued)

1961

"Seattle's Artist of the People." C.L. Anderson. *Seattle Times* 9 April.

1963

"William Cumming Paintings on View in Area." Thelma Lehmann. *Seattle Post-Intelligencer* 16 October.

"Testy Prophet Hits Stride as Major Painter." Tom Robbins. *Seattle Times* October.

1964

"Cumming Influence Felt at Exhibition." Ann Faber. *Seattle Post-Intelligencer* 9 November.

1965

"William Cumming Tackles Football." Tom Robbins. *Seattle Times* 31 October..

"Art Students Need Fundamentals." William S. Cumming. *Seattle Times* 10 October.

"Cumming Views a Few Heroes." Anne G. Todd. *Seattle Times* 28 November.

1966

"Fragments of a Journal." William Cumming. *Puget Soundings* June.

1967

"Iconoclasm Works Well for Cumming." Anne G. Todd. *Seattle Times* 10 June.

1968

"For the Love of Art." Sally Hayman. *Seattle Post-Intelligencer* 23 June.

1973

"William Cumming at the Beach." Maggie Hawthorn. *Seattle Post-Intelligencer* 3 June.

"The Cumming Thing: Shadow and Mass." Deloris Tarzan. *Seattle Times* 3 June.

1974

"Seattle and Puget Sound." Martha Kingsbury. *Art of the Pacific Northwest.* Washington, D.C.: Smithsonian Institution, National Collection of Fine Arts.

1975

"Artists' Shadows Have No Smile." Deloris Tarzan. *Seattle Times* 23 November.

1977

"Powerful William Cumming Exhibit." R.M. Campbell. *Seattle Post-Intelligencer* 27 March.

"Cumming Paints Tough Images." Deloris Tarzan. *Seattle Times* 27 March.

James Fitzgerald

Born in Seattle, 1910. Received Bachelor of Architecture degree, University of Washington, 1935. Studied painting and drawing at Kansas City Art Institute and Colorado Springs Fine Arts Center, 1937-1938. Received Carnegie Graduate Fellowship to Yale University, 1938-1939. Married artist Margaret Tomkins, 1939. During the war, in charge of production illustration at Boeing Company 1941-1945. Completed first sculptural commission, design of relief in concrete at eastern entrance of tunnel for Lake Washington floating bridge, Seattle, 1945. Had one-man exhibitions of paintings at Seattle Art Museum, San Francisco Art Museum, Santa Barbara Museum of Art; and included in numerous group exhibitions in major museums throughout United States, 1946-1954. Painted in Seattle studio and isolated Lopez Island studio, 1948-1954. When Seattle studio and home destroyed by fire, involvement in sculpture became dominant, 1959. Major sculpture commissions of the sixties include U.S. Courthouse and Federal Office Building, Ogden, Utah; School of Public and International Affairs, Princeton University, Princeton, New Jersey; and bronze and glass screen, Seattle Public Library. Major fountain commissions include Washington State University, Pullman; Western Washington State University, Bellingham; Seattle Civic Center Playhouse courtyard. Established own bronze foundry, 1964. Had first one-man exhibition at Catherine Viviano Gallery, New York, 1969. Instructor in art at Kansas City Art Institute; Colorado Springs Fine Arts Center; University of Washington; and Spokane Arts Center. Died 1973.

1963

"Sculptor Shows Nature in State of Crisis." Tom Robbins. *Seattle Times* 24 November.

"Sculpture Show Rewarding." Thelma Lehmann. *Seattle Post-Intelligencer* 25 November.

1965

"James Fitzgerald—His Bronzes Are Cast in His Own Foundry." Tom Robbins. *Seattle Times* 12 November.

1969

Fitzgerald. New York: Catherine Viviano Gallery.

1970

"Seattle Turns Its Climate Into Art." Sally Hayman. *Seattle Post-Intelligencer* 8 February.

1973

"James Fitzgerald, Seattle Sculptor, Dies." *Seattle Times* 9 November.

Richard Gilkey

Born in Bellingham, Washington, 1925. Family pioneered in Skagit Valley. Moved to Seattle, 1935. Worked as miner before serving in U.S. Marine Corps during World War II. Returned to Seattle after marines and painted in skid road studio under influence and instruction of Guy Anderson, Morris Graves, and Mark Tobey, 1945-1949. Traveled four months in Belgium, France, and Italy; and saw paintings by the masters for first time, 1948. Until 1970 Seattle was home base, but consistently painted in Skagit Valley, occasionally renting studios in Stanwood, La Conner, and Florence. Awarded Guggenheim Fellowship, 1958. Painted landscape in Ireland for six months; and visited museums in England, France, Italy, and Spain, 1958. First major one-man exhibition held at Seattle Art Museum, 1960. Has been consistent contributor to regional invitational and juried shows at Seattle Art Museum, Henry Gallery at University of Washington, and State Capitol Museum in Olympia, Washington. Retrospective exhibition held at Whatcom Museum of History and Art, Bellingham, 1978. Lives in remodeled studio-house in Skagit Valley near La Conner.

1955

"Artist 'Purges' Self to Find Style." John Voorhees. *Seattle Post-Intelligencer* 9 August.

1957

"Diversity Marks Art Exhibition." John Voorhees. *Seattle Post-Intelligencer* 1 October.

1960

"Painter Richard Gilkey's Star on Ascendancy." Ann Faber. *Seattle Post-Intelligencer* 23 September.

"Gilkey Remembers Day Visiting with Picasso." Anne G. Todd. *Seattle Times* 9 October.

1963

"Gilkey's Stark Oils Have Energy, Rhythm." Thelma Lehmann. *Seattle Post-Intelligencer* 7 March.

"Richard Gilkey is a Painter of Grim Integrity." Tom Robbins. *Seattle Times* 17 March.

"The Northwest Keeps Drawing Him Back." Paul V. Thomas. *Seattle Times* 27 October.

1970

"Gilkey Shows What Painting is All About." John Voorhees. *Seattle Times* 30 September.

1978

Richard Gilkey Paintings. Bellingham, Washington: Whatcom Museum of History and Art. Includes checklist with statement by Richard Gilkey.

Morris Graves

Born in Fox Valley, Oregon, 1910. Moved to Seattle as a child. Traveled to Orient three times as cadet on American Mail Lines before age twenty. Had begun painting by 1932, early oils in heavy paint. Shared studio with Guy Anderson in Edmonds, Washington and made six-month sketching trip to Los Angeles, 1934. First one-man exhibition held at Seattle Art Museum, 1936. Worked on WPA Federal Art Project, Seattle, 1936-1939, painted Red Calf Series and Message Series. Settled in La Conner, Washington and began close association with Mark Tobey, 1938-1939; produced Nightfall Pieces, Purification Series, Moons, Snakes, and Chalices. Built isolated studio-home, "The Rock," on Fidalgo Island, 1940; painted there for extended periods until 1947, Inner Eye Series, Joyous Young Pine Series, Journey Series, Old Pine Top Series, Leaf Series, Crane Series. Joined staff of Seattle Art Museum, 1940-1942. Inducted into army, 1942-1943. Developed further interest in Zen philosophy, 1945. Awarded Guggenheim Fellowship for study in Japan, but permitted only as far as Hawaii because of war, 1946-1947; began Chinese Bronze Series. Moved away from "The Rock" and began building home in Edmonds, 1947. Traveled to Europe, painted for one winter in Chartres, France, 1948-1949. Returned to Seattle, 1949, Bouquet Series. Moved to Ireland, 1954-1956, painted Hibernating Animals. Returned to Seattle; awarded grant from National Institute of Arts and Letters, 1956. Produced Spring with Machine Age Noise

Morris Graves (continued)

Series and returned to Ireland, 1957. Began Ant War Series and Insect Series, 1958. Bought house in Ireland, 1959. Traveled around world, 1961-1963. Returned to United States and bought property near Loleta, California, 1964. Traveled to Asia, Africa, South America, Near East, early seventies; and to India, 1978. Has exhibited internationally and is represented in major museum collections in United States. Has been given numerous one-man shows, including retrospective exhibition organized by Art Galleries of University of California at Los Angeles, which traveled to seven participating museums, 1956. Second retrospective was held at Museum of Art, University of Oregon, Eugene, 1966. Lives in wooded area near Loleta, California.

1956

Morris Graves. Los Angeles: Art Galleries of University of California. Includes Foreword by John Baur; "About the Technic," Duncan Phillips; "Morris Graves," Frederick S. Wight.

1962

"Pacific Northwest." Henry J. Seldis. *Art in America* January-February.

1965

"Regional Accent: The Northwest." Wallace S. Baldinger. *Art in America* January-February.

1966

Morris Graves. Eugene: University of Oregon Museum of Art. Includes Foreword by Wallace S. Baldinger; "Something About Morris Graves," Nancy Wilson Ross; "Religious Symbolism in the Works of Morris Graves," Virginia Haseltine.

"The Metaphysical Morris Graves." Tom Robbins. *Seattle Magazine* February.

"The Muted Gravesian Universe." Alfred Frankenstein. *San Francisco Examiner* 13 March.

1967

"Morris Graves: Don't Let His Birds Get in the Way." Tom Robbins. *Seattle Post-Intelligencer* 1 October.

1974

"Seattle and Puget Sound." Martha Kingsbury. *Art of the Pacific Northwest.* Washington, D.C.: Smithsonian Institution, National Collection of Fine Arts.

"Series Re Morris Graves." John Cage. *Drawings of Morris Graves.* Boston: New York Graphic Society. Includes Preface by David Daniels, comments by Morris Graves.

1975

"New Morris Graves." R.M. Campbell. *Seattle Post-Intelligencer* 22 January.

"The Special World of Morris Graves." R.M. Campbell. *Seattle Post-Intelligencer* 23 November.

1976

"Summer of '34." Wallace Graves. *Puget Soundings* June.

"The Prophetic Art of Morris Graves." Part I by Rachael Griffin, Part II by David C. Mendoza. *Oregon Rainbow* Summer.

1977

"Morris Graves in Retrospect." Matthew Kangas. *Artweek* January.

1978

"Graves Flowers at Foster." Deloris Tarzan. *Seattle Times* 15 January.

"The Flowering Spirit of Morris Graves." Robert C. Arnold. *Argus* 20 January.

"Morris Graves." R.M. Campbell. *Seattle Post-Intelligencer* 22 January.

Paul Horiuchi

Born at foot of Mt. Fuji, Kawaguchi, Japan, 1906. Studied sumi brush techniques for three years with artist, Iketani. Came to United States in 1922 and settled with family in Rock Springs, Wyoming. Became United States citizen, 1928. Moved to Seattle, 1946. Encouraged as artist by Zen master, Takazaki, who introduced him to Mark Tobey. Developed close friendship with Tobey through mutual interest in Zen philosophy and Japanese antiques. Began principal medium, collage, 1956, inspired by frayed posters and notices on outdoor bulletin boards in Seattle's Chinatown. First major one-man exhibition, Zoe Dusanne Gallery, Seattle, 1957. First one-man exhibition at Seattle Art Museum in 1958. Returned to Japan in 1964 to paint for first one-man show at Nordness Gallery, New York, 1964. Has exhibited regularly in Northwest and throughout United States, including retrospective exhibition in 1969 held at both Museum of Art, University of Oregon, Eugene, and Seattle Art Museum. Represented in major museum collections. Major commissions include 17 by 60 foot free-standing ceramic tile mural on Seattle Center grounds, 1962. Lives in Seattle.

1957

"Horiuchi Exhibit at Dusanne Gallery Showcases a Major Talent." Ann Faber. *Seattle Post-Intelligencer* 19 May.

William Ivey

1959

"Dusanne Art Gallery Show Worth Two." John Voorhees. *Seattle Post-Intelligencer* 8 October.

1961

"Paul Horiuchi." Ann Faber. *Art International* May.

1962

"Pacific Northwest." Henry J. Seldis. *Art in America* January-February.

"Horiuchi Mural to be Added to City's Treasures." Thelma Lehmann. *Seattle Post-Intelligencer* 25 May.

1963

"Collage Master is Better than Ever." Tom Robbins. *Seattle Times* 5 May.

"New York Sees Horiuchi Again." Tom Robbins. *Seattle Times* 8 December.

1965

"Regional Accent: The Northwest." Wallace S. Baldinger. *Art in America* January-February.

"Horiuchi Has It: A Stroke of Fortune." Ann Faber. *Seattle Post-Intelligencer* 14 May.

1967

"Artist Framed by His Ancestors." Sally Hayman. *Seattle Post-Intelligencer* 12 November.

1969

"50 Years of Painting Surveyed." Jean Batie. *Seattle Times* 23 March.

Paul Horiuchi: 50 Years of Painting. Seattle and Eugene: Seattle Art Museum and University of Oregon. Includes essay by Barbara Lane.

1974

"Interview with Paul Horiuchi." *Seattle News Journal* 1 May.

"Horiuchi Collages Strong at Woodside." Deloris Tarzan. *Seattle Times* 17 May.

"Vibrant Colors of Paul Horiuchi." Susan McAllister Brown. *Seattle Post-Intelligencer* 26 May.

"Seattle and Puget Sound." Martha Kingsbury. *Art of the Pacific Northwest.* Washington, D.C.: Smithsonian Institution, National Collection of Fine Arts.

1975

"Horiuchi Collages: More Is Less." Deloris Tarzan. *Seattle Times* 16 November.

"The Subtle Collages of Paul Horiuchi." R.M. Campbell. *Seattle Post-Intelligencer* 16 November.

1976

"A Horiuchi Show at the Woodside." R.M. Campbell. *Seattle Post-Intelligencer* 3 December.

Born in Seattle, 1919. Studied law at University of Washington, and art, simultaneously, at Cornish School of Allied Arts, Seattle, 1937-1941. Entered army as paratrooper, 1941-1946. Studied with Mark Rothko, Clyfford Still, and Ad Reinhardt at California School of Fine Arts, San Francisco, 1946-1948. Inspired by works of Portland artist, C.S. Price, 1947. Returned to Seattle to develop personal style of abstract expressionism, 1948. Received Ford Foundation Purchase Award, 1960. Received grant from National Foundation for the Arts and Humanities, 1962. First one-man exhibition held at Seattle Art Museum, 1964, again in 1975. Had first one-man exhibition in Europe, Galerie Arnaud, Paris, 1966. In 1967, was awarded Rockefeller Fellowship and was artist-in-residence at Reed College, Portland. Has had numerous exhibitions throughout United States and has exhibited regularly in Northwest at Gordon Woodside Gallery since 1960. Lives in Seattle.

1962

"Pacific Northwest." Henry J. Seldis. *Art in America* January-February.

1966

"Paintings by Ivey Have No Neat Label." Anne G. Todd. *Seattle Times* 12 October.

"Compelling Ivey Show at Woodside." Ann Faber. *Seattle Post-Intelligencer* 21 October.

1973

"Woodside Promotes Love of Ivey." Deloris Tarzan. *Seattle Times* 19 October.

1974

"Seattle and Puget Sound." Martha Kingsbury. *Art of the Pacific Northwest.* Washington, D.C.: Smithsonian Institution, National Collection of Fine Arts.

1975

William Ivey. Seattle: Seattle Art Museum. Includes Introduction by Virginia Wright.

"William Ivey Emerging from Obscurity." R.M. Campbell. *Seattle Post-Intelligencer* 2 February.

1977

"Splendid Ivey-Covered Walls." Steven Winn. *The Weekly* 16 November.

"Ivey Still Clings to Abstraction." Deloris Tarzan. *Seattle Times* 18 November.

Leo Kenney

Born in Spokane, Washington, 1925. Moved to Seattle with family, 1931. Encouraged to study Seattle Art Museum collection, particularly Tobey and Graves, by Jule Kullberg, artist and art instructor at Broadway High School. Deeply impressed by surrealist and symbolist writing and painting which influenced work from forties to early sixties. Spent winters with family in Long Beach, California, 1943-1949. Met Seattle painters Guy Anderson, Morris Graves, Leona Wood, and Clifford Wright; and had first exhibitions at Frederick & Nelson's Gallery of Northwest Art and at Helen Bush School, 1944. First one-man exhibition held at Seattle Art Museum, 1949. Moved to Long Beach, 1949. Had close association with former Seattle artist, Leona Wood, and worked as riveter at Douglas Aircraft Company, 1950-1951. Worked in display departments at Gumps and W. & J. Sloane, San Francisco, 1952-1959. More reductive, symmetrical work replaced earlier figurative work after one-time experience with mescaline, 1962. Returned to Seattle with major show of new work at Scott Galleries, 1964. Awarded grant from National Institute of Arts and Letters, 1967. First one-man exhibition at Willard Gallery, New York, 1968. Has had numerous exhibitions throughout United States, and exhibitions regularly in the Northwest, including retrospective at Seattle Art Museum, 1973. Represented in major museum collections. Lives in Seattle.

1968

"Heir to Tobey and Graves." Tom Robbins. *Seattle Magazine* March.

"Leo Kenney Has N.Y.C. Showing." Jean Batie. *Seattle Times* 28 April.

"West Coast Report: The Pacific Northwest Today." Peter Selz with Tom Robbins. *Art in America* November-December.

1972

"The Progression of Leo Kenney." Stephanie Miller. *Seattle Post-Intelligencer* 26 November.

1973

Leo Kenney. Seattle: Seattle Art Museum. Includes "Leo Kenney: The Early Years," Leona Wood; "Leo Kenney: An Adventure of the Imagination," Tom Robbins.

1974

"Seattle and Puget Sound." Martha Kingsbury. *Art of the Pacific Northwest.* Washington, D.C.: Smithsonian Institution, National Collection of Fine Arts.

1977

"Graves, Kenney Share Show." Deloris Tarzan. *Seattle Times* 16 January.

Carl Morris

Born in Yorba Linda, California, 1911. Studied at Art Institute of Chicago, 1931-1933. Studied in Europe at Kunstgewerbeschule and Akademie der Bildenden Kunst, Vienna, 1933-1935; and in Paris at Université des Etats-Unis on International Education Fellowship, 1935-1936. Returned to United States and worked on motion picture sets in Los Angeles, 1936-1937. First one-man exhibition in America at Paul Elder Gallery, San Francisco, 1937. Taught at Art Institute of Chicago, 1937-1938. Was director for WPA Federal Art Project at Spokane Art Center, 1938-1939. In 1940 married sculptor Hilda Grossman; lived in houseboat on Lake Union, Seattle; established art school in studio; and started long friendship with Mark Tobey. Moved to Portland, won WPA Federal Art Project competition for mural in Eugene, Oregon, 1941. Worked as draftsman during war years, 1942-1945. Developed highly personal abstract style during the forties and fifties. First one-man exhibition at Portland Art Museum, 1952. Taught at University of Colorado, Boulder, 1957. Has exhibited regularly in Northwest and nationally, including retrospective exhibition circulated by American Federation of Arts, New York, 1960-1962. Represented in major museum collections. Major commissions include nine 8 by 10 foot mural panels on world religions for Hall of Religion at Oregon Centennial Exposition, 1959. Lives in Portland.

Hilda Morris

1952

Carl Morris, A Decade of Painting. Portland: Portland Art Museum. Includes Introduction by Priscilla C. Colt, notes by Carl Morris.

1957

"Carl and Hilda Morris Back as Exhibitors." Margaret B. Callahan. *Seattle Times* 18 November.

1960

Carl Morris. New York: American Federation of Arts. Includes essay by Grace L. McCann Morley.

1962

"Pacific Northwest." Henry J. Seldis. *Art in America* January-February.

1965

"Regional Accent: The Northwest." Wallace S. Baldinger. *Art in America* January-February.

1966

"Morris Has Large Show at Woodside." Anne G. Todd. *Seattle Times* 4 November.

1973

"Seeing the Light at Woodside." Deloris Tarzan. *Seattle Times* 4 March.

1974

"Portland and Its Environs." Rachel Griffin. *Art of the Pacific Northwest.* Washington, D.C.: Smithsonian Institution, National Collection of Fine Arts.

Born in New York, 1911. Studied at Cooper Union School of Art and Architecture and at Art Students League, New York. Married sculptor Carl Morris and lived in houseboat on Lake Union, Seattle, 1940. Moved to Portland, 1941. First solo exhibition at Portland Art Museum, 1946; again in 1955. Awarded Ford Foundation Fellowship, 1960. Cast large bronzes in Italy for major exhibition at Portland Art Museum same year, 1974. Continuing work with traditional sumi techniques has complimented development of personal three-dimensional calligraphic style. Has exhibited regularly in Northwest and internationally, including Metropolitan Museum of Art and Museum of Modern Art, New York; Museums of Modern Art, Sao Paulo and Rio de Janeiro, Brazil; and American Federation of Arts traveling exhibitions. Major sculpture commissions include *Muted Harp,* Seattle Opera House, 1963; *The Ring of Time,* Standard Plaza, Portland, 1967; and *Sea Myth,* Pacific National Building, Tacoma, 1971. Represented in major museum collections throughout the United States. Lives in Portland.

1962

"Pacific Northwest." Henry J. Seldis. *Art in America* January-February.

1965

"Regional Accent: The Northwest." Wallace S. Baldinger. *Art in America* January-February.

1969

"Sculpture as Metaphor: Five Bronzes by Hilda Morris." Robin Skelton. *Malahat Review.*

1973

Hilda Morris, Recent Bronzes. Carolyn Kizer. Portland, San Francisco, Seattle: Gallery of Art, Triangle Gallery, and Gordon Woodside Gallery.

1974

"Portland and Its Environs." Rachael Griffin. *Art of the Pacific Northwest.* Washington, D.C.: Smithsonian Institution, National Collection of Fine Arts.

Ambrose Patterson

Clayton S. Price

Born in Daylesford, Australia, 1877. Studied at National Gallery, Melbourne, Academie des Beaux Arts, Academie Julien, and Colorassi, Paris; and painted in Belgium, Brittany, England, Ireland, and Spain, 1898-1910. Traveled to Canada and New York where did cartoons and artwork for *Montreal Witness* and *New York Herald Tribune.* Returned to Paris, 1901, and was awarded American Art Association Prize; was included in famous first exhibition at Salon d'Automne, Paris, 1903. Exhibited at Royal Academie and Baillie Gallery, London, 1904. Had major exhibition in Brussels at Cercle Artistique et Litteraire, where was founding member, 1906. In 1910 returned to Australia and painted commissioned portraits of eminent countrymen. Painted in Hawaii, 1915-1917. Arrived in Seattle and did free lance work, 1918. Joined staff at University of Washington where established School of Painting and Design, 1919. In 1921 had first one-man show at Seattle Fine Arts Society, predecessor of Seattle Art Museum, and subsequent one-man shows, 1934, 1947, and 1956. Studied with André Lhote in Paris, 1929-1930. Studied in Mexico for fresco paintings to be done later in Seattle, 1934. Retired from University of Washington, professor emeritus, 1947. Painted, studied, and traveled extensively with wife, artist Viola Patterson. Exhibited regularly in Northwest and internationally, including major retrospective at Seattle Art Museum, 1961, and memorial retrospective at Cellar Gallery, Kirkland, 1967.

Represented in major museum collections, United States, Europe, and Australia. Died 1966.

1939

Modern Art in America. Martha Chandler Cheney. New York: McGraw-Hill.

1947

"Review of Patterson Retrospective at Seattle Art Museum." Kenneth Callahan. *Seattle Times* 12 January.

"Artist-Professor." Margaret B. Callahan. *Seattle Times* 23 February.

1960

"Ambrose Patterson: Artist." Jo Ann Davis. *Seattle Times* 10 April.

1961

"Retrospectives Show Artists' Dedication." Anne G. Todd. *Seattle Times* 15 October.

1966

"Ambrose Patterson, U.W. Professor, Artist, Dies." *Seattle Post-Intelligencer* 28 December.

1967

Ambrose Patterson. Kirkland, Washington: Cellar Gallery. Includes checklist with Introduction by Spencer Moseley.

"Patterson Paintings Viewed in Kirkland." Jean Batie. *Seattle Times* 18 October.

1974

"Seattle and Puget Sound." Martha Kingsbury. *Art of the Pacific Northwest.* Washington, D.C.: Smithsonian Institution, National Collection of Fine Arts.

Clayton S. Price

Photograph by Minor White

Born in Bedford, Iowa, 1874. Moved with family to Wyoming, 1884. Worked as cowhand, carrying sketchbook, 1895-1908. Studied one year at St. Louis School of Fine Arts, where met Charles Russell, 1905. Moved to Portland and worked two years as illustrator for *Pacific Monthly* (now *Sunset*), 1909. Moved to San Francisco Bay area, where exposed to European painting for first time, 1915. Did odd jobs in Portland and Canada to support concentration on nonillustrative art. Moved back to Monterey, California, where lived and painted full-time in house formerly occupied by Robert Louis Stevenson, and led small group of artists struggling to break away from impressionism, 1918-1927. First one-man exhibition, Beaux-Arts Gallery, San Francisco, 1925. One-man exhibition, Berkeley League of Fine Arts, 1927. Returned to Portland, 1928. Worked intermittently on WPA Federal Art Project, including completion of three large murals, 1933-1940. First retrospective, Portland Art Museum, 1942, and one-man exhibition, 1949. First one-man exhibition at Valentine Gallery, New York, 1945. Awarded honorary Master of Arts degree from Reed College, Portland, 1948. In last years developed abstract figurative style with scumbled surfaces and somber earth colors. Exhibited regularly in Northwest and throughout United States including Museum of Modern Art, New York, 1946; memorial exhibition initiated by Portland Art Museum and Walker Art Center, traveling to nine United States museums,

Mark Tobey

1951; and major retrospective at Portland Art Museum, 1976. Represented in major museum collections throughout United States. Died 1950.

1942

C. S. Price. Portland: Portland Art Museum. Includes Introduction by Robert T. Davis.

1943

Romantic Painting in America. Dorothy C. Miller, and James Thrall Soby. New York: Museum of Modern Art.

1945

"C.S. Price, Modernist, Comes Out of the West." Jo Gibbs. *Art Digest* 15 March.

1946

Fourteen Americans. Dorothy Miller. New York: Museum of Modern Art.

"Pacific Northwest." Kenneth Callahan. *Art News* July.

1948

Sixteen by C. S. Price. Portland: Reed College.

1950

"Long Train," *Time* 2 January.

1951

C. S. Price, A Memorial Exhibition. Portland and Minneapolis: Portland Art Museum and Walker Art Center. Includes notes by Gerald Nordland and Francis J. Newton.

"Death Brings Artist Fame." Margaret B. Callahan. *Seattle Times* 29 April.

1965

"Regional Accent: The Northwest." Wallace S. Baldinger. *Art in America* January-February.

American Painting in the 20th Century. Henry Geldzahler. New York: Metropolitan Museum of Art.

1974

"Portland and Its Environs." Rachael Griffin. *Art of the Pacific Northwest.* Washington, D.C.: Smithsonian Institution, National Collection of Fine Arts.

1975

"Price of Portland on View at PNAC." Deloris Tarzan. *Seattle Times* 1 April.

1976

A Tribute to C. S. Price. Portland: Portland Art Museum. Includes Introduction by William Chiego; notes by C.S. Price, Kenneth Callahan, Carl Morris, Lloyd Reynolds, and Charles Heaney.

Photograph by Johsel Namkung

Born in Centerville, Wisconsin, 1890. Spent childhood with family in Tennessee, Wisconsin, and Indiana, 1890-1908. Sent by father to Saturday classes at Art Institute of Chicago, 1908. Moved with family to Chicago, where found work as commercial artist, 1909-1911. Traveled back and forth between Chicago and New York working as fashion artist and doing numerous charcoal portraits, 1911-1917. Given first one-man exhibition of portrait drawings, M. Knoedler & Co., New York, 1917. Joined Bahai World Faith about 1918. Moved to Seattle and found teaching position at Cornish School of Allied Arts, 1923-1924. Met Teng Kuei, Chinese student at University of Washington, who introduced him to Chinese brushwork, 1923. Traveled to Europe and Near East, 1925-1927. Returned to Seattle, 1927. Divided time between Seattle, Chicago, and New York, 1927-1929. Traveled in Mexico, 1931. Was resident artist at Dartington Hall, Devonshire, England, 1931-1938. Traveled in Europe, 1932, and Orient, 1934. Spent one month in Zen monastery in Kyoto, Japan, where studied calligraphy and painting, wrote poetry, and meditated, 1934. Painted *Broadway Norm, Broadway,* and *Welcome Hero,* initiating style later known as "white writing," about 1935. First exhibition at Seattle Art Museum, 1935. Moved back to Seattle from England, worked on WPA Federal Art Project for six months; then began teaching in studio, 1938. Painted pictures based on three-year study of Seattle's Pike Place Public Market, 1943. Given first of many one-man

exhibitions, Willard Gallery, New York, 1944, marking beginning of national reputation. Retrospective exhibition held at San Francisco Palace of the Legion of Honor, which traveled to Seattle, Santa Barbara, and New York, 1951. Had first of many one-man exhibitions at Otto Seligman Gallery, Seattle, 1954. Given first one-man exhibition at Galerie Jeanne Bucher, Paris, 1955, marking beginning of international reputation. Awarded first prize for painting, XXIX International Biennial, Venice, 1958. Settled in Basel, Switzerland, 1960. Was first American to be given exhibition at Musée des Arts Décoratifs (Palais du Louvre, Pavillon de Marsan), Paris, 1961. Major retrospective exhibition held at Museum of Modern Art, New York, which traveled to Cleveland and Chicago, 1962-1963. Completed mural, *Journey of the Opera Star,* commissioned in 1962, for Seattle Opera House, 1964. Other major retrospectives include Dallas Museum of Fine Arts, 1968; Seattle Art Museum, 1971; and Smithsonian Institution, National Collection of Fine Arts, Washington, D.C., 1974. Represented in major museum collections around the world. Died, Basel, 1976.

1951

Mark Tobey. New York: Whitney Museum of American Art.

1959

Mark Tobey. Colette Roberts. New York: Grove Press.

1961

Mark Tobey. Françoise Choay. Paris: Fernand Hazan.

Mark Tobey. Paris: Musée des Arts Décoratifs.

1962

Mark Tobey. New York: Museum of Modern Art. Includes essay by William Seitz.

1964

Mark Tobey: The World of a Market. Seattle: University of Washington Press. Includes Introduction by Mark Tobey.

1965

Mark Tobey. Basel: Editions Beyeler. Includes Introduction by John Russell with tributes by John Cage, Naum Gabo, and Lyonel Feininger.

1966

Mark Tobey. Amsterdam: Stedelijk Museum. Includes Introduction by Wieland Schmied.

1968

Mark Tobey Retrospective. Dallas: Dallas Museum of Fine Arts. Includes Introduction by Merrill C. Rueppel.

Mark Tobey (continued) **Margaret Tomkins**

1970

Tobey's 80, a Retrospective. Seattle: Seattle Art Museum. Includes Foreword by Richard E. Fuller, Introduction by Betty Bowen.

1974

Tribute to Mark Tobey. Washington, D.C.: Smithsonian Institution, National Collection of Fine Arts. Includes Introduction by Joshua Taylor.

"Seattle and Puget Sound." Martha Kingsbury. *Art of the Pacific Northwest.* Washington, D.C.: Smithsonian Institution, National Collection of Fine Arts.

1976

Mark Tobey, 1930-67: A Selection of Work from the Seattle Art Museum. Miami Dade South: The Art Gallery. Includes Introduction by Willis F. Woods.

Born in Los Angeles, 1916. Studied at University of Southern California, Los Angeles, receiving Bachelor of Fine Arts degree in 1938, and Master of Fine Arts degree in 1939. Moved to Seattle to become assistant professor of art at University of Washington, 1949; guest professor of art, 1962, 1972. Married Seattle sculptor, James Fitzgerald, 1940. First solo exhibition held at Seattle Art Museum, 1941. Taught at Spokane Art Center, 1941-1942. Had solo exhibition at Seattle Art Museum, which traveled to California Palace of the Legion of Honor, San Francisco, 1947. Painted during summers in studio on Lopez Island, Washington, intermittently, 1947-1975. Exhibited at Artists Gallery, Seattle, a cooperative organized with Fitzgerald, Bunce, Ivey, Izquierdo, and Mason, 1958. Fire destroyed Seattle studio and paintings, 1959. Traveled to Europe, 1961. Given solo exhibition, Henry Gallery, University of Washington, 1962. Traveled to Greece and Turkey, 1973. Moved to isolation of Lopez Island studio, 1975. Given major retrospective exhibition, Washington State University, Pullman, 1977. Other major solo exhibitions include Evergreen State College Art Gallery, Olympia, and Whatcom Museum of Art, Bellingham, both 1978. Has exhibited regularly in Northwest and been included in numerous important national exhibitions. Lives on Lopez Island.

1962

"Paintings Sprang From Ashes." Anne G. Todd. *Seattle Times* 28 October.

"Viewers Will 'Float' at Gallery." Thelma Lehmann. *Seattle Post-Intelligencer* 19 November.

1964

"Tomkins' Stage-Whispers Say a Lot." Tom Robbins. *Seattle Times* 17 May.

1974

"Seattle and Puget Sound." Martha Kingsbury. *Art of the Pacific Northwest.* Washington, D.C.: Smithsonian Institution, National Collection of Fine Arts.

1977

"Margaret Tomkins." Deloris Tarzan. *Seattle Times.* 6 March.

Margaret Tomkins. Pullman, Washington: Museum of Art, Washington State University. Includes Introduction by Patricia Grieve Watkinson, notes by Margaret Tomkins and Tom Robbins.

1978

Margaret Tomkins, Paintings and Sculpture, 1969-1978. Bellingham, Washington: Whatcom Museum of History and Art. Includes checklist with Introduction by George E. Thomas.

George Tsutakawa

Born in Seattle, 1910. Sent to Japan for education and grew up in atmosphere of Buddhism, Shintoism, and Zen philosophy, 1917-1927. Returned to Seattle, having studied European art and music in Japan, 1927. Exhibited block prints, 1930-1936. Studied sculpture with Dudley Pratt and Archipenko, and painting with Ambrose Patterson and Walter Isaacs at University of Washington, 1932-1937, receiving Bachelor of Arts and Master of Fine Arts degrees, 1937. About 1938 met Seattle artists Guy Anderson, Morris Graves, Mark Tobey, Kenneth Callahan, and William Cumming; and shared mutual interest in Orient. Drafted into army and taught Japanese, 1942-1946. Taught Japanese, University of Washington, 1946. Began teaching art at University of Washington in 1947, where he remains. Visit to Japan in 1956 (again in 1969 and 1975) stimulated creative period in which began work on *Obos,* sculpture series inspired by Tibetan practice of piling rocks in tribute to nature. Traveled to Europe, 1963, and to Mexico, 1964 and 1974. In 1958, received first fountain commission, Seattle Public Library. Subsequent fountain commissions include: Lloyd Center, Portland, 1961; Sunken Plaza, Commerce Tower, Kansas City, 1964; Ala Moana Center, Honolulu, 1966; Washington State Ferry Terminal, Pier 41, Seattle, 1966; and Expo '74, Spokane, Washington, 1974. Had major one-man exhibition of sumi paintings at gallery of Pacific Northwest Arts Council of Seattle Art Museum, 1976. Traveled to Tibet, 1977. Nominated to National Academy of Arts and Letters, 1978. Besides numerous commissions has exhibited regularly in Northwest and nationally. Lives in Seattle.

1958

"Change in Style." *Seattle Times* 18 May.

"George Tsutakawa Has Indoor-Outdoor Show." Ann Faber. *Seattle Post-Intelligencer* 25 May.

1962

"Pacific Northwest." Henry J. Seldis. *Art in America* January-February.

1963

"George Tsutakawa. *Artforum* August.

1965

"Our Heart is a Fountain." Ann Faber. *Seattle Post-Intelligencer.* 19 September.

1966

"Welding in Modern Metal Sculptures." Jack M. Uchida. *Welding Journal* February.

1969

"The Fountains of George Tsutakawa." Gervais Reed. *A.I.A. Journal* July.

1974

"Seattle and Puget Sound." Martha Kingsbury. *Art of the Pacific Northwest.* Washington, D.C.: Smithsonian Institution, National Collection of Fine Arts.

1976

"Sumi cum laude: Tsutakawa." Deloris Tarzan. *Seattle Times* 29 February.

"George Tsutakawa." Gervais Reed. *Journal of Ethnic Studies* Spring.

1977

"Old Friends Just Get Better." Deloris Tarzan. *Seattle Times* 25 March.

Mark Tobey
Northwest Still Life, 1941

Tempera on board, 20×26
Eugene Fuller Memorial Collection
Seattle Art Museum

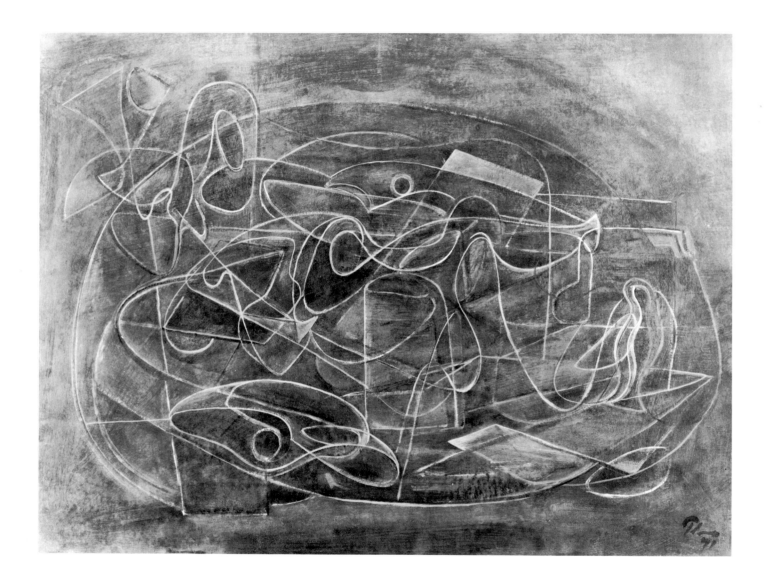

Checklist of the Exhibition

Height precedes width in all dimensions listed.

Guy Anderson

Sharp Sea, ca. 1944, p. 36

Dry Country, 1955, p. 37

Deception Pass through Indian Country,
1959, p. 39

Primitive Forms II, 1962, p. 35

Dream of the Language Wheel, 1962
Oil on board, 96 x 48
Collection of Anne and John Hauberg

Spring (Stop the Bomb), 1967, p. 26

Birth of Adam, 1969-1970
Oil on paper on board, 96 x 72
Collection of Robert M. Sarkis

Louis Bunce

City Memories, 1941
Gouache, 16 x 20
Courtesy of Gordon Woodside Gallery, Seattle

Still Life, 1962, p. 12

Work in Progress, 1964, p. 67

Kenneth Callahan

Northwest Landscape, 1934, p. 44

Chasm, 1943
Gouache on upsom board, 16¼ x 21½
Eugene Fuller Memorial Collection
Seattle Art Museum

Rocks and People, 1945-1946, p. 17

Mountain Landscape, 1951, p. 42

The Seventh Day, 1952-1953, p. 19

Echoes of Ancient Battle, 1955
Tempera on paper, 17¼ x 22
Eugene Fuller Memorial Collection
Seattle Art Museum

Night of Soliloquy, 1956
Oil on canvas, 50 x 50
Gift of the artist
Seattle Art Museum

Riders on the Mountain, 1956, p. 45

The Storm, 1961
Oil on canvas, 19½ x 37½
Gift of Mr. and Mrs. Paul Roland Smith
Seattle Art Museum

Insect, 1966, p. 43

Ebb and Flow, 1968, p. 41

William Cumming

Abandoned Factory, 1941, p. 70

Worker Resting, 1941, p. 76

Two Loggers, 1944, p. 23

Moppets, 1960
Tempera on board, 39 x 28¼
Collection of Mr. and Mrs. A. Gordon Bennett

Nude, 1966, p. 107

James Fitzgerald

Resurgent Sea, 1945, p. 69

Trees, 1958
Wax tempera in oil
and emulsion on board, 48 x 11¾
Sidney and Anne Gerber Collection
Seattle Art Museum

Astroweb, 1962, p. 78

Richard Gilkey

Untitled (Swamp Grass), 1960
Oil on board, 27¾ x 35
Collection of Anne and John Hauberg

Bridge, 1963, p. 85

Leek Still Life, ca. 1966, p. 77

Morris Graves

Moor Swan, 1933, p. 4

Self Portrait, 1933
Oil on canvas, 30 x 24
Collection of Mr. and Mrs. Max Weinstein

Burial of the New Law, 1936, p. 28

Woodpeckers, 1940
Gouache on paper, 30⅝ x 20⅝
Eugene Fuller Memorial Collection
Seattle Art Museum

Haunted Bouquet, 1943
Gouache on paper, 30½ x 27
Eugene Fuller Memorial Collection
Seattle Art Museum

Journey, 1943
Gouache on paper, 19¾ x 30¼
Eugene Fuller Memorial Collection
Seattle Art Museum

Owl, 1943, p. 29

Sea, Fish, and Constellation, 1943, p. 31

Waning Moon: No. 2, 1943, p. 15

Bird Sensing the Essential Insanities, 1944, p. 27

Concentrated Old Pine Top, 1944, p. 30

Leaves Before Autumn Wind, ca. 1944
Casein on mulberry paper, 31⁷⁄₁₆ x 57¹⁵⁄₁₆
Gift of Mr. and Mrs. Bagley Wright
Seattle Art Museum

Asian Bloom, 1945
Gouache on paper, 42½ x 24¾
Gift of Mr. and Mrs. Kenneth Fisher
Seattle Art Museum

Ambrose Patterson
Puyallup Fair, 1940

Watercolor on paper on wood, 14¼ x 21¾
Gift of Mrs. Thomas D. Stimson
Seattle Art Museum

**Consciousness Achieving the Form of
a Crane,** 1945
Gouache on paper, 42¾ x 24⅝
Eugene Fuller Memorial Collection
Seattle Art Museum

Ceremonial Bronze Taking the Form of a Bird,
1947, p. 32

Spring, 1950, p. 66

August Still Life, 1952
Oil on canvas, 48½ x 40¾
The Phillips Collection, Washington, D.C.

Mid-Century Hibernation, 1954
Tempera on paper, 20 x 15¾
Eugene Fuller Memorial Collection
Seattle Art Museum

Resilient Young Pine, ca. 1955
Tempera, 72½ x 37
Collection of Fay F. Padelford

Bird, No. 4 (The Multicolored One), 1969
Gouache on paper, 12⅝ x 12⅝
Eugene Fuller Memorial Collection
Seattle Art Museum

Paul Horiuchi

Torrential Rains, 1957
Casein on rice paper on board, 30 x 24
Eugene Fuller Memorial Collection
Seattle Art Museum

December No. 2, 1959
Casein and collage of mulberry paper on canvas,
34½ x 60¼
45th Annual Exhibition of Northwest Artists Purchase Fund
Seattle Art Museum

Trail in the Snow, 1959
Casein on paper, 34⅞ x 22¹⁵⁄₁₆
Eugene Fuller Memorial Collection
Seattle Art Museum

Genroku Era, 1960, p. 34

Monolythic Impasse, 1964
Casein and collage of mulberry paper on canvas, 72 x 79
Collection of Mr. and Mrs. Paul Horiuchi

Drums for Drama, 1966, p. 73

William Ivey

Landscape, 1961, p. 81

Drawing, 1963, p. 60

Wheatfield, 1967, p. 59

Leo Kenney

The Inception of Magic, 1945, p. 68

Third Offering, 1945, p. 14

Camera Obscura, 1963, p. 72

Heavenly Lens, 1963
Tempera and gauze on paper, 16¾ x 16¾
Collection of Anne and John Hauberg

Seed and Beyond II, 1964
Gouache on paper on wood, 19¼ x 15
Eugene Fuller Memorial Collection
Seattle Art Museum

Vertical Transformation, 1966
Gouache on paper, 46 x 22
Collection of Anne and John Hauberg

Carl Morris

Out of the Coulee, 1946, p. 82

Archaic Script, 1961
Oil on canvas, 45 x 58
Lawrence H. Bloedel Bequest
Whitney Museum of American Art
New York.

Mortal Shore, 1963-1964, p. 25

Hilda Morris

On a Spindle of Light, 1961
Sumi on paper, 32 x 38
Collection of Anne and John Hauberg

Captive Reach, ca. 1967
Bronze, 33½ x 5
Private collection

Double Round, 1968, p. 75

Ambrose Patterson

Puyallup Fair, 1940, p. 104

Rocky Landscape, 1946, p. 83

Summer, 1952, p. 8

Portage Bay, 1954
Oil on canvas, 31 x 44⅛
Eugene Fuller Memorial Collection
Seattle Art Museum

Yulan or Denudata, 1964
Watercolor, 40 x 30
Collection of Anne and John Hauberg

Clayton S. Price

Boats, 1930s, p. 88

Horses in Landscape, ca. 1948, p. 24

Mark Tobey

Near Eastern Landscape, 1927, p. 65

Moving Forms, 1930, p. 87

Rising Orb (Bahai Series), 1935, p. 47

Table and Ball, 1936
Gouache on paper, 10½ x 19½
Eugene Fuller Memorial Collection
Seattle Art Museum

Modal Tide, 1940
Oil on canvas, 34½ x 47⅜
West Seattle Art Club, Katherine B. Baker
 Memorial Purchase Prize
26th Annual Exhibition of Northwest Artists
Seattle Art Museum

Farmer's Market, 1941, p. 10

Forms Follow Man, 1941, p. 22

Northwest Still Life, 1941, p. 102

Rummage, 1941
Gouache on fiberboard, 38⅜ x 25⅞
Eugene Fuller Memorial Collection
Seattle Art Museum

Still Life with Egg, 1941
Tempera, 10⅝ x 17
Eugene Fuller Memorial Collection
Seattle Art Museum

Still Life with White Plane, 1941
Gouache on board, 17⅝ x 21¾
Eugene Fuller Memorial Collection
Seattle Art Museum

Broadway Boogie, 1942
Tempera, 30 x 23¼
Private collection

E Pluribus Unum, 1942
Tempera on paper on board, 19¾ x 27¼
Gift of Mrs. Thomas D. Stimson
Seattle Art Museum

White Night, 1942, p. 20

Working Man, 1942, p. 71

Gothic, 1943, p. 50

Point Five-Vertical, 1943
Gouache on board, 28½ x 19⅛
29th Annual Exhibition of Northwest Artists Purchase Fund
Seattle Art Museum

Western Splendor, 1943
Egg tempera on board, 25¾ x 19¼
Gift of Marillyn Black Watson
Seattle Art Museum

Bars and Flails, 1944, p. 74

Electric Night, 1944, p. 52

Eskimo Idiom, 1946
Tempera on board, 43½ x 27½
Gift of Mr. and Mrs. Sam Rubinstein
Seattle Art Museum

Skid Road (Skid Road Scavenger Series),
 1948, p. 84

Self Portrait (detail), 1949, p. 46

Pacific Cloud, 1950
Gouache on paper, 12⅞ x 18¼
Eugene Fuller Memorial Collection
Seattle Art Museum

Universal City, 1951
Gouache on paper on masonite, 37½ x 25
Gift of Mr. and Mrs. Dan Johnson
Seattle Art Museum

Orpheus, 1952
Gouache on paper, 18⅝ x 25⅜
Gift of Mr. and Mrs. Corydon Wagner
Seattle Art Museum

Festival, 1953
Tempera and oil on cardboard, 39½ x 29½
Gift of Mr. and Mrs. Bagley Wright
Seattle Art Museum

Golden Mountains, 1953
Gouache on masonite, 39¼ x 18¼
Eugene Fuller Memorial Collection
Seattle Art Museum

Northwest Phantasy, 1953, p. 51

Canals, 1954
Gouache on paper, 17¾ x 11⅞
Eugene Fuller Memorial Collection
Seattle Art Museum

Choir II, 1954
Gouache on paper, 16½ x 10
Eugene Fuller Memorial Collection
Seattle Art Museum

Serpentine, 1955, p. 57

June Night, 1957
Gouache on paper, 11⅝ x 17⅞
Eugene Fuller Memorial Collection
Seattle Art Museum

Space Ritual, No. 1, 1957, p. 53

Written Over the Plains, No. 2, 1959, p. 56

Winter Patterns III, 1961
Tempera and glue on paper on board, 9⅝ x 8⅝
Gift of Dr. and Mrs. Richard E. Fuller
Seattle Art Museum

Parnassus, 1963, p. 54

Garden, 1965
Tempera on board, 22½ x 17¼
Eugene Fuller Memorial Collection
Seattle Art Museum

Signs and Messengers, 1967, p. 48

Variations, 1970, p. 55

Margaret Tomkins

Anamorphosis, 1944, p. 79

Lineage, 1948
Egg tempera on gesso ground, 21⅛ x 23⅞
Music and Art Foundation Purchase Prize
35th Annual Exhibition of Northwest Artists
Seattle Art Museum

Abstraction, 1961
Oil on canvas, 71 x 93½
Collection of Naramore, Bain, Brady and Johanson
 Architects, Seattle

Night Passage, 1961, p. 80

George Tsutakawa

Deep in My Memory, 1950, p. 61

Obos No. 1, 1956
Teak, 22 x 8¾
Collection of the artist

Obos No. 2, 1958, p. 6

Mt. Walker, 1970, p. 86

William Cumming
Nude, 1966

Ink on paper, 10¼ x 6
Collection of the artist

Lenders to the Exhibition

Mr. and Mrs. A. Gordon Bennett

William Cumming

Anne and John Hauberg

Mr. and Mrs. Paul Horiuchi

Naramore, Bain, Brady and Johanson Architects,
 Seattle

Fay F. Padelford

The Phillips Collection, Washington, D.C.

Robert M. Sarkis

George Tsutakawa

Mr. and Mrs. Max Weinstein

Whitney Museum of American Art, New York

Gordon Woodside Gallery, Seattle

Designed by Douglas Wadden.

Black and white photography by Paul Macapia.
Color photography by Johsel Namkung.
Photographs of the artists by Mary Randlett,
except where otherwise indicated.

Lithography by Graphic Arts Center, Portland, Oregon.
Binding by Lincoln and Allen, Portland, Oregon.
Set in various sizes of Helvetica. Printed on Vintage Velvet
text in an edition of 35,000 soft bound and 3,000 cloth.
Cover and jacket are printed on Kromkote.